FOTOGRAFIKS

An equilibrium between
PHOTOgraphy AND Design through graphic expression that evolves
FROM CONTENT.

TEXT BY PHILIP B. MEGGS
FOTOS+DESIGN BY DAVID CARSON

LAURENCE KING

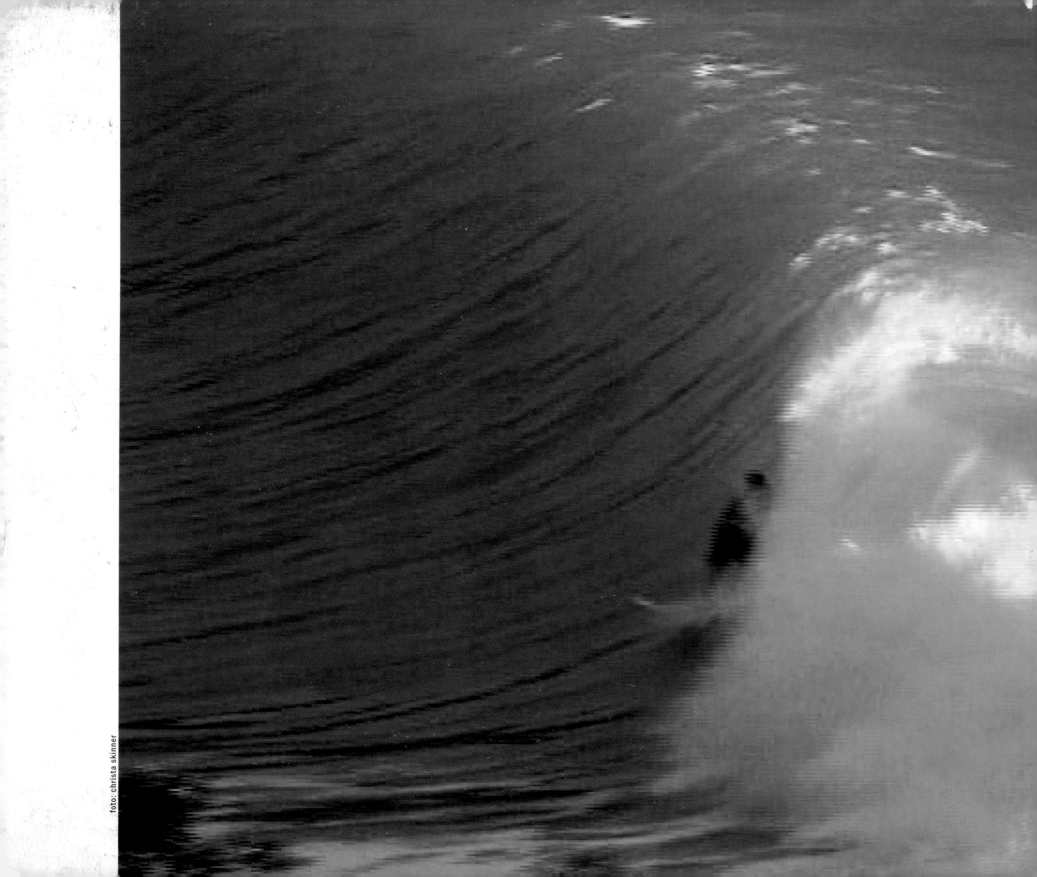

or Fotografiks Photography with a [GRAPHIC DESIGN] attitude.

FOR LUKE

The great leap from Joseph Niepce to David Carson

When first encountering David Carson's images, I felt compelled to place them in the context of the early days of photography: its struggle to obtain legitimacy as an art form, and the way that it came to radically alter culture. The first two sections of this book, "Photography changed everything" and "Is photography art?", establish a broad context from which David's fotografiks, or the work of any contemporary photographer, might be viewed. The third section, "Photography + Graphic Design = Fotografiks" considers the particular attitude that graphic designers often bring to their photography. The final sections – "David Carson, Graphic Designer" and "On David Carson's photography" – discuss David's graphic design and photography, the interaction of which is the *raison d'être* of this book. —*pbm*

* * *

01. Photography changed everything

Revolutions often occur so slowly that people in the midst of change barely notice how their world is being radically altered. The changes caused by photography extend over decades while its technical and aesthetic advances have impacted on experience and communication.

Photography began around 1826 when a crusty old French tinkerer, Joseph Niepce, placed a sheet of pewter coated with a light-sensitive material inside his camera obscura. By exposing this sheet to sunlight streaming through the lens and then using a solvent to wash away the areas not hardened by light, he produced the world's first photograph. He described his sun pictures as "fixing light". Niepce died a few years later, oblivious to the impending reconstruction of human culture wrought by the improvement and perfection over decades of photographic processes.

A photographic record was created of people, places, and things. Recorded history had to face the new visual documentation. People's understanding of ancestry was modified, and their memories were shaped by these visual mementos. The very nature of history changed forever.

During the nineteenth century, photographic half-tone printing plates ended the reign of the engraver and helped to turn printing into a medium of mass communication. By 1900, full-color artwork could be reproduced with great fidelity, spurring the rise of the illustrator as an important maker of mass-produced images. As the twentieth century progressed, photographs in magazines and newspapers printed in millions presented wars, fashions, and heroes throughout the world. Photographed models became the reference point for people's self-images and "celebrity" changed from being a verbal to a visual phenomenon.

Art became liberated once photography freed painting and sculpture from their roles as recorders of people, places, history, and religion. Traditional art media became "art for art's sake", with artists inventing forms instead of copying from nature. From cubists to abstract expressionists, the artist's role was that of inventor and explorer, rather than representationalist.

Science was not immune to photography's transforming power. Micro-photography, stop-action photography, and comparative analyses of photographic documentation enabled scientists to study everything from bacteria to air patterns flowing over vehicles; they even proved that horses leave the ground when running.

By taking twenty-four frames a second with a motion-picture camera, cinematographers pushed photography's redefining power into the realm of the fourth dimension. Aerial photography, strobe lights, photojournalism, and instant photography: these and scores of other developments altered our perception of the world, and thereby changed our world.

On very personal levels, photography affects the lives of individuals. Almost everyone has a photograph of themselves; these mirrors of personal existence alter self-perceptions. Most households own a camera and record their family history. People such as David Carson use photography as a tool to extend and document their perceptual experience. Original vision is transformed from an ephemeral private experience into public documentation.

Niepce never saw the sweeping transformation of human culture caused by his rudimentary invention. Our science, our art, and perhaps most importantly, our view of ourselves and our world have all been radically altered.

o2. is
photog-
raphy
ART?

tool for expressing thought and feeling of a purely artistic kind." **3**

Why did it take decades for photography to win acceptance as art? Photography's mechanical and chemical technologies for creating a precise, repeatable image of the natural world built a reputation for accurate documentation, made with a veracity accepted as legal evidence in court. Perhaps this numbing power to capture the truth at 1/125 of a second became a major stumbling block in photography's struggle for legitimacy as an art form.

The reputation for truth, gravely tarnished by advertising's dependence upon alteration before and after the shutter is snapped, has now been totally destroyed by digital manipulation. Idealized images of people, places, and things transform the ordinary into a canon of beauty repeated over and over in printed matter, showing people an image of life as it never really quite happens. Photography became an instrument for altering our identity while creating lust for products that define our being.

The antidote for the photographic trash polluting our sight and distorting our understanding of the world is an integrity of vision. A camera is more than a light preserver when placed in the hands of a sensitive person. Carrying a camera at the ready changes one's life, experience, and response to the world. Every corner, every glance, holds a possibility. A camera-carrier, whether a professional, amateur, or artist, sees the world with vigilant eyes. This persistence of vision finds enchantment, awareness, and even poetry in the world. This is the antidote; this is the art.

The debate over photography's legitimacy as art began early on. Only two years
after William Henry Fox Talbot announced his positive/negative photographic
process in 1839, he recalled: "It was said by many persons, at the time
when photogenic drawing was first spoken of, that it was likely to prove
injurious to art, as substituting mere mechanical labor in lieu of talent
and experience." After noting that there was "ample room for exercise of
skill and
judgement" by controlling variations in exposure and fixing time for
varied
artistic effects, Talbot concluded: "I feel confident that such an alliance
of science with art will prove conducive to the improvement of both." **1**

Sixty years later, little progress toward the acceptance of photog-
raphy as art had been made, prompting Alfred Stieglitz to write about
"The
sneer of those not willing to give certain photographic pictures rank as
works of art." **2**

At the turn of the century, O.W. Beck said: "It is vehemently
denied by a majority that photography is or ever can be art..." But Beck
had hope, believing that photography "will in course of time become a
remarkable

1William Henry Fox Talbot, "Calotype (Photogenic) Drawing", *Literary Gazette*, 13 February 1841.
2Alfred Stieglitz, "The 'Champs de Mars' Salon and Photography". *Camera Notes* Vol. VI No. 1, July 1902, p. 50.
3O.W. Beck, "The Art Education of the Photographer". *Camera Notes*, Vol. V No. 1, July 1901, p. 3.

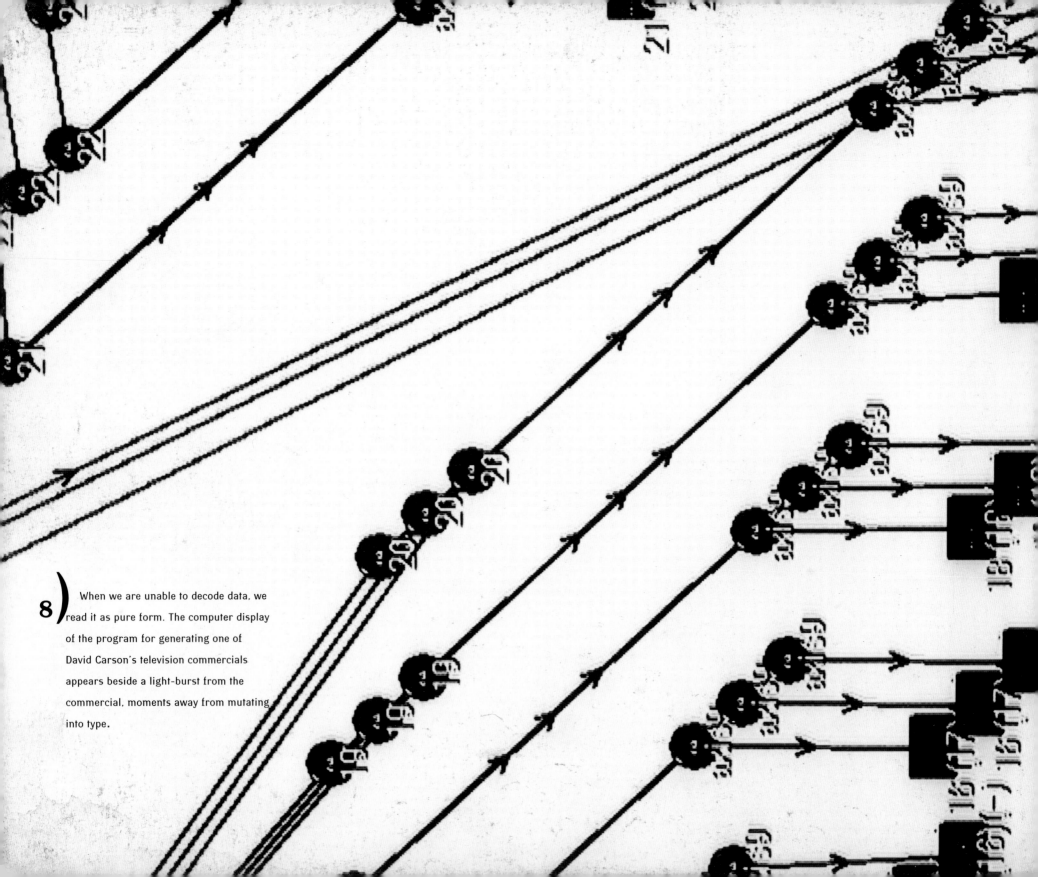

8) When we are unable to decode data, we
read it as pure form. The computer display
of the program for generating one of
David Carson's television commercials
appears beside a light-burst from the
commercial, moments away from mutating
into type.

[10]

Photographs of photographs remain photographs, while the photograph photographed is often perceived as the real thing. When first viewing these fish, I asked David if he photographed them at the Fulton Fish Market. Then I saw the door.

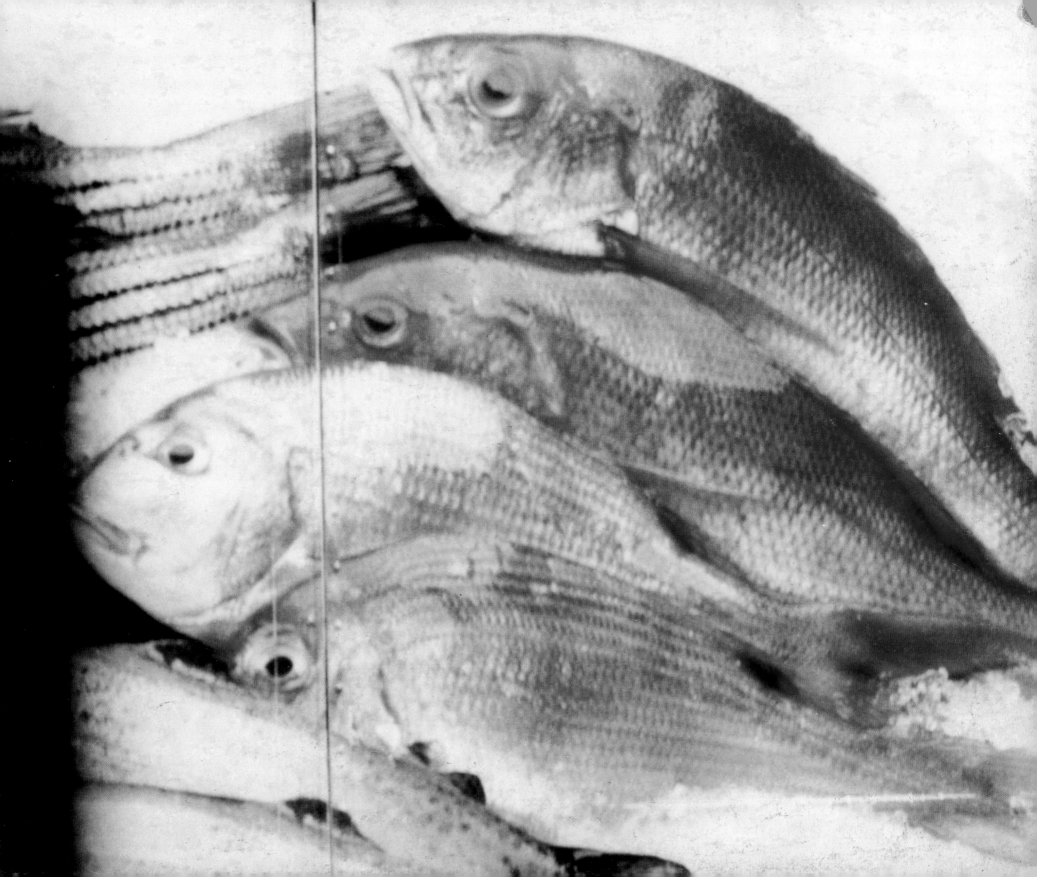

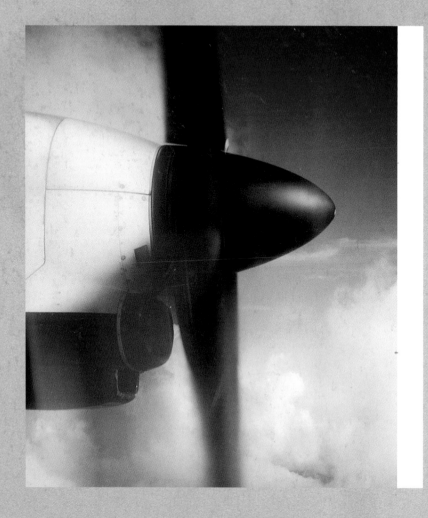

03.Photography +Graphic DESIGN= Fotografiks

I'm glad that David Carson titled this book "Fotografiks" instead of "Photographs", because it is as much about graphic design as it is about photography. Fotografiks is a good word because it lends itself to several complex meanings and can be approached from opposite directions—from design to photography. or vice versa.

fotografiks implies an approach to photography based on a designer's viewpoint. Many designers take photographs. With their passion for the visual manifestation of abstract symbols. especially numbers and letters, they delight in documenting vernacular graphics in the environment.

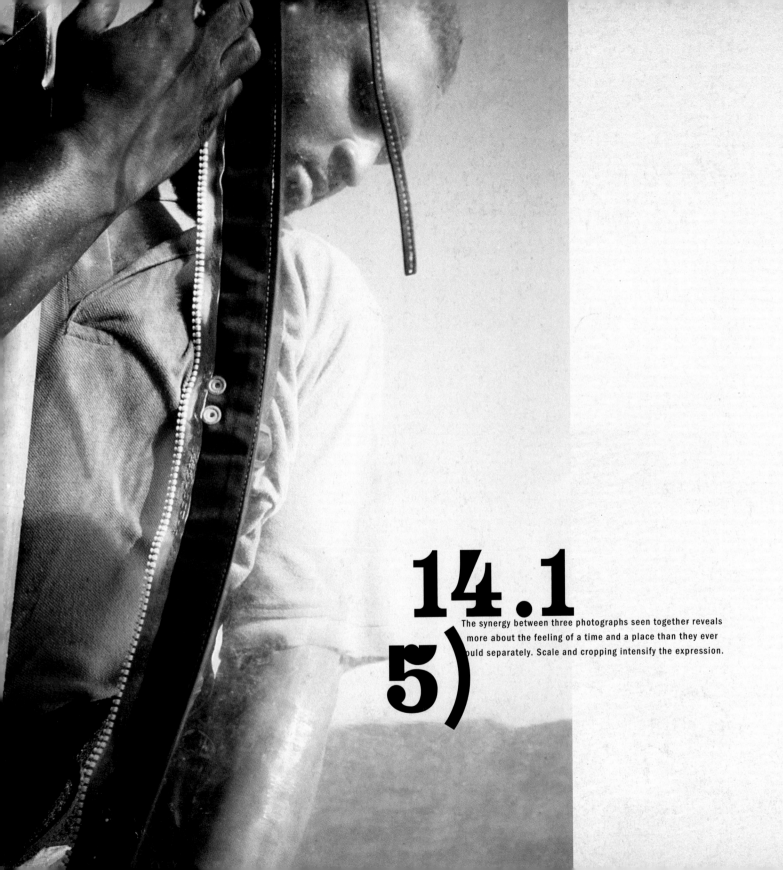

14.1

5)

The synergy between three photographs seen together reveals more about the feeling of a time and a place than they ever ould separately. Scale and cropping intensify the expression.

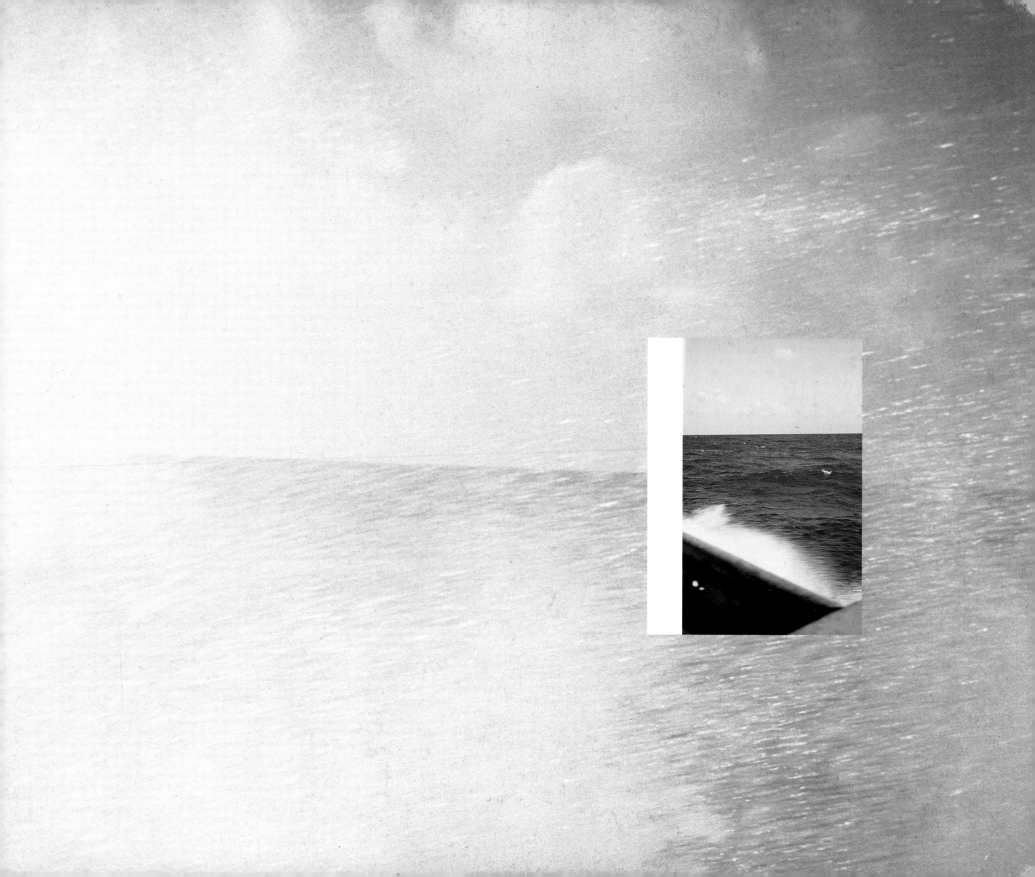

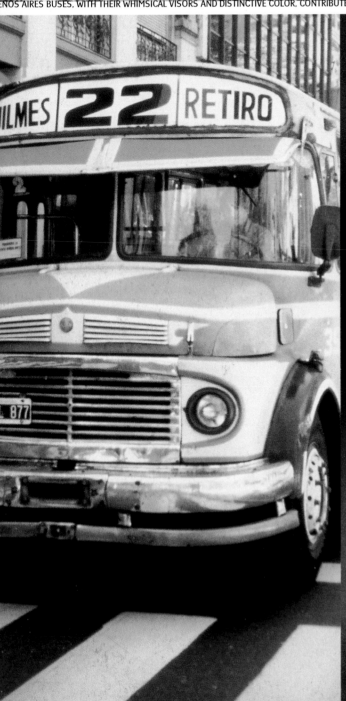

Found compositions, textural surfaces, and color themes are recorded as inspiration; perceptual experiences are documented. Usually designers photograph without ulterior motives, such as reproducing, selling, or exhibiting their **images.**

Another level of meaning embraces the integration of photography and typography into a unified whole that is greater than the sum of its parts. This possibility was championed by László Moholy-Nagy when he coined the term "typophoto" in the 1920s. He envisioned a new approach to posters through the unification of words and pictures to communicate a message with immediacy. Graphic design often involves a yin-yang duality, when a synergy between words and images is achieved.

Designers see the page, not the photograph, as the locus of their creative enterprise. They understand words and pictures, not merely as two separate language systems to be politely placed together on a page, but as communications media receptive to dynamic interaction in both form and message. The goal is a holistic visual/verbal **message.**

As the designer of hundreds of magazine spreads, David Carson formed attitudes about this visual/verbal interface and its potential for expression. While designing *Transworld Skateboarding* magazine from 1983–87, Carson often found it necessary to design with existing photographs of marginal quality. He confronted a perpetual challenge in trying to invent a way to make the photograph and layout more interesting and dynamic for the viewer. Photographs become raw material vulnerable to extension and improvement through processes used by graphic designers to create pages—image selection, cropping, juxtaposition, overlapping, bleeding, collaging, scale change, and integration with other **elements.**

The designer's view of a photograph as an element in a more complex communication flies in the face of the notion of the photograph as a precious work of art, not to be violated. Certainly, there are photographs whose content and visual attributes warrant deference as autonomous works of art, but these are in a small **minority.**

In most photography books, each picture is plunked in the center of a page in the manner of a museum catalog. This preserves the integrity of the photograph, but makes for bland book design. In the merged role of photographer and designer, Carson is able to have a dialog between two mediums of expression. He can even torment and torture his images without fear of violating the integrity of another person's **work.**

Co-presence means the appearance of two or more attributes together at the same time. Photographs and type each have their own separate co-presence. A photograph is primarily viewed as the subject matter depicted, but it has a secondary presence as a two-dimensional surface containing a pattern of tones or colors. When viewed in this way, the visual attributes of color (or value) and space become an additional level of perceptual experience and a potent non-pictorial expression. This second presence is often the attribute that separates masterworks from **snap shots.**

Type has a special co-presence. It principally exists as phonetic symbols to be decoded through reading. On a secondary level, text type functions as a textural surface of forms (letters) and counterforms (the unprinted areas between the letters), while large display type can be viewed as a composition of shapes interacting with their ground or field. With words and pictures, their secondary presence brings expression to the primary **message.**

Yet another level of co-presence occurs when photographs and type are joined on the printed page. In addition to their ability to connote and change a viewer's interpretation of each other, their visual properties also begin to form potent levels of meaning. Jockeying co-presence into a coherent and expressive message is the essence of graphic **design.**

(In one of the most courageous creative acts of the twentieth century, Wassily Kandinsky liberated the painted image from co-presence around 1910, when he pushed from expressionistic landscape painting into the realm of subject-matterless abstract expressionism, but that's another story.)

Fotografiks can never follow Kandinsky into the realm of non-objective art, because it is about language, with **form adding expression to the message.**

18.19]

This enigmatic tower looming over the French landscape reminds us how people in different countries solve similar problems with different designs. Door hinges, toilet handles, window latches, water towers, and silos often possess native traits.

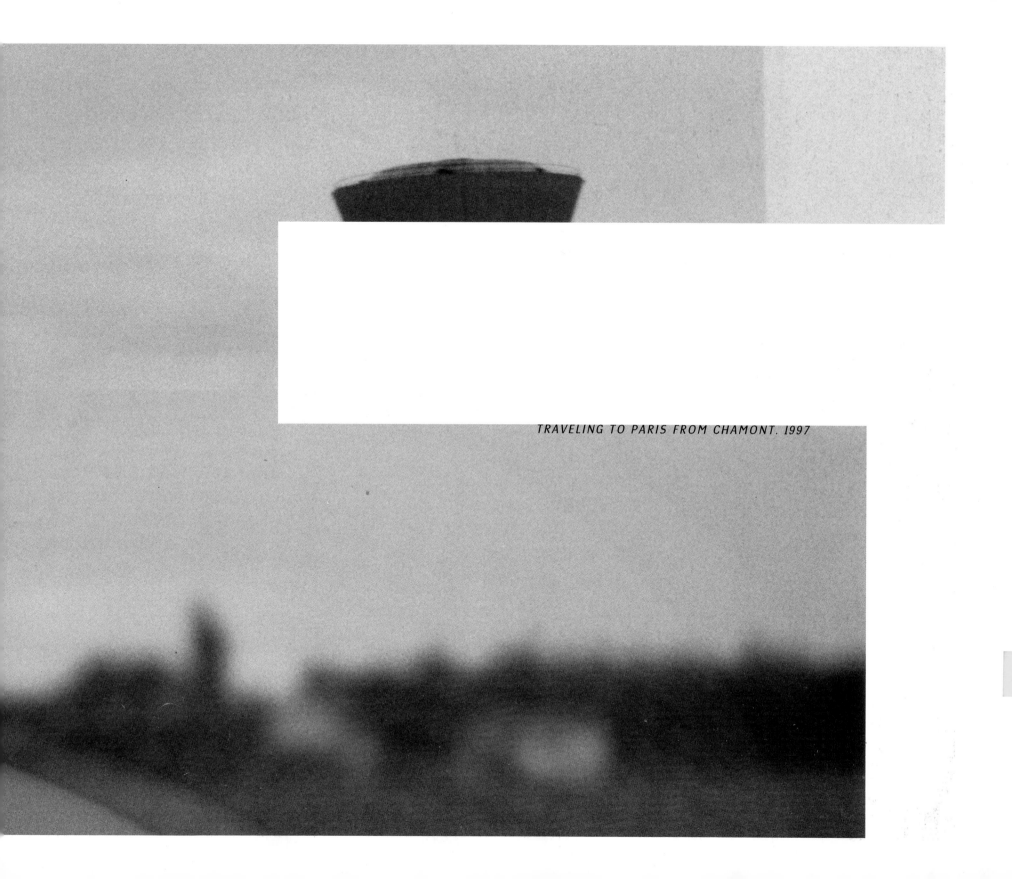

TRAVELING TO PARIS FROM CHAMONT. 1997

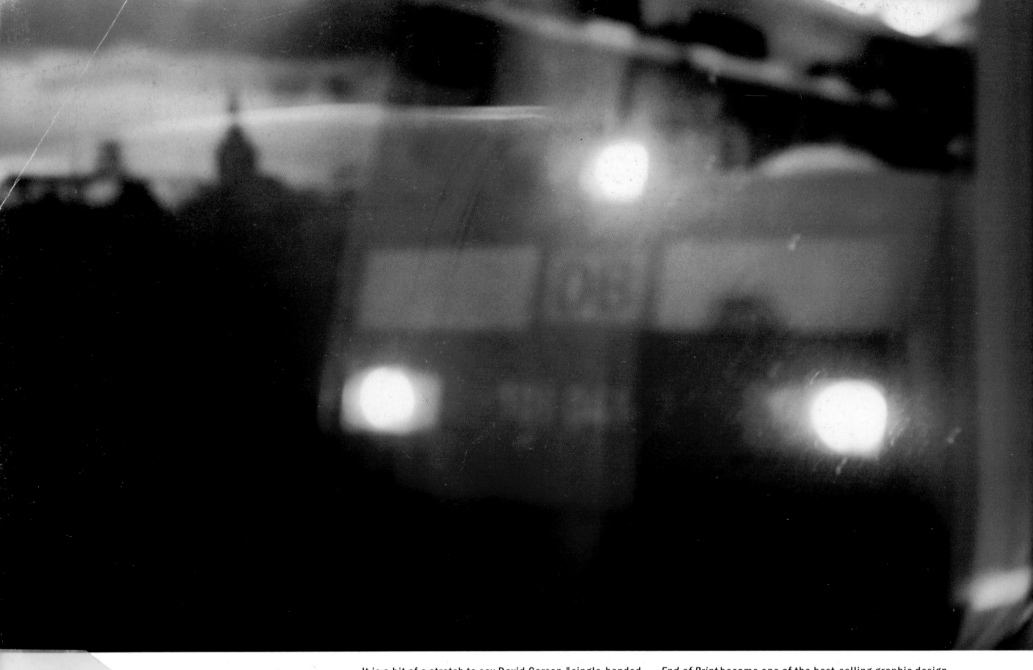

o4
David Carson, GRAPHIC designer

It is a bit of a stretch to say David Carson "single-handed-ly changed the course of graphic design", a claim made by the Chronicle Books marketing department in 1995 when it prepared the flap copy for the initial printing of Carson's first book, *The End of Print: The Graphic Design of David Carson*. Carson was embarrassed by this claim, and he became even more chagrined when a book review-er mistakenly wrote that Carson himself had made this claim "on the cover of his book". The flap copy was rewrit-ten at Carson's request for subsequent printings, as *The End of Print* became one of the best-selling graphic design books in history.

This little controversy prompts the question: why all the fuss about Mr. Carson? Why have his detrac-tors been so quick to damn his work, while a book review-er seizes upon a publisher's marketing copy to thrash him? Why have noted design spokespersons uttered phrases such as "the degeneration of Western culture" and "the cult of the ugly" in their condemnation of inno-vative designs of the 1990s?

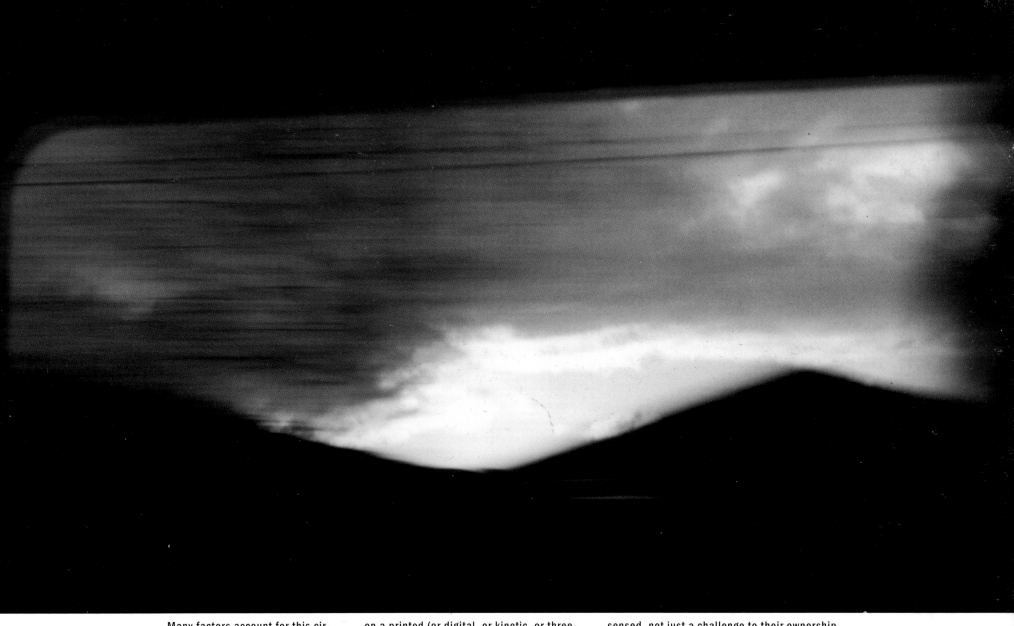

Many factors account for this circumstance. We are experiencing a watershed shift in human culture as the old order gives way to whatever comes next. One factor in this cataclysmic change is the fracturing of boundaries between creative disciplines; another is the disintegration of graphic design into several pronounced directions. One of these routes might be best described as the rise of the graphic designer-cum-artist. These individuals - whose approach to type and image on a printed (or digital, or kinetic, or three-dimensional) surface involves questioning the traditional syntax of visual communications - have made graphic design more expressive and less formulaic. Traditional methods for organizing information on a surface are defied; new digital typefaces defile norms of letterform design; and images are digitally defaced.

These developments traumatized established graphic design professionals who sensed, not just a challenge to their ownership of the holy grail, but a rejection of their standards and aesthetics. They were blinded by seismic shifts in design thinking. A conspiracy of technology and humanism jolted their boat, and they never even saw it coming.

Perched on the roof of the movement, Carson became a lightning rod for all the voltage hurled at the new design approach. Among designers struggling to redefine graphics in the digital age, Carson's art direction and

20-21 Travel time goes against the established patterns of human activity, affording impressions of light not normally seen in our daily routines.

cont.

design of widely available magazines made him the most prolific, most visible, and the most conspicuous designer of his generation.

A scientist once told me the working definition for research is "when I am doing what I don't know what I'm doing". Carson's approach to design and photography encompasses a similar aspect of open-ended exploration. For the better part of two decades, he has steadily explored new paths, questioned past accomplishments, and experimented with new possibilities. One need only look at his layouts for surfing magazines in the early 1980s to realize that experimentation isn't a passing stage in Carson's career, but a way of life.

Musing on his design work, in 1996 Carson told *Print* magazine: "I didn't try to break rules. I lacked a built-in restrictive understanding of how things are supposed to be done. It's just that I didn't know what the rules were." 4

Carson majored in sociology and graduated from San Diego State University in 1977. He studied graphic design briefly in 1980, then accepted an internship at Surfer Publications. Carson isn't completely self-taught as is often stated, for apprenticing as a journeyman graphic designer at a magazine publishing firm is no different from the apprenticeships used to educate artists from the medieval era until the second half of the nineteenth century, when more formal schooling for aspiring artists became the norm.

Just before the computer revolution re-formed graphic design, Carson was catapulted to international design prominence as art director/designer of *Beach Culture* (1989–91). This influential publication was followed by *Surfer* (1991–92) and *Ray Gun* (1992–96). Currently he maintains an independent design office in New York, designing a host of projects including (but not limited to) advertisements, music videos, posters, publications, television commercials, and trademarks.

4Philip B. Meggs, "Five Top Designers Confess: 'I Never Went to Art School!'" *Print*, Vol. 50 No. 3, May/June 1996, p. 128.

vid
n,
HIC
r

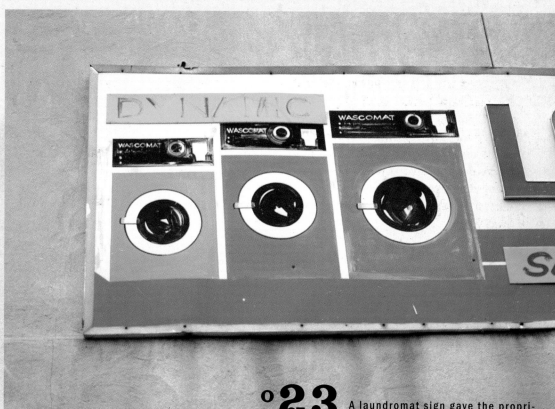

°**23.** A laundromat sign gave the proprietor an opportunity to indulge in color—something that rarely happens in his daily life.

[5] MARSHALL McLUHAN, UNDERSTANDING MEDIA: THE EXTENSIONS OF MAN, SECOND EDITION, NEW YORK 1966, P. 175.

[6] PETER C. BUNNELL, ED., EDWARD WESTON ON PHOTOGRAPHY, SALT LAKE CITY 1983, P. 68.

[7] I WAS TOLD THIS BY ONE OF MY TEACHERS YEARS AGO, BUT I'VE NEVER BEEN ABLE TO DOCUMENT A SOURCE.

[8] SADAKICHI HARTMANN, "A FEW REFLECTIONS ON AMATEUR AND ARTISTIC PHOTOGRAPHY", CAMERA NOTES VOL. II NO. 2, NEW YORK 1898, P. 42.

[9] PETER C. BUNNELL, ED. OP. CIT. P. 70.

05 on David Carson's photography

David Carson is an amateur photographer. But before this statement brings forth outrage from his supporters while causing his detractors to click their heels in glee, let me assert that amateurs have played a major role in human progress, **while professionals often obstruct innovation.**

Marshall McLuhan's observation—the "vested interests of acquired knowledge and conventional wisdom have always been by-passed and engulfed by new media"—strikes to the heart of the professional's contemporary dilemma.[5] One who is trained in the correct methods of professional photography or graphic design is continually ambushed as technological innovations and new creative directions challenge conventional wisdom.

Amateurs (and in one sense, all true artists are amateurs) often engage in innovative thinking simply because no one ever told them what the experts had declared to be great truth. Charles Goodyear's vulcanization of rubber, Benjamin Franklin's invention of the lightning rod, and the assembly of the first Apple home computer in a garage by Steve Wozniak and Steve Jobs, are just three examples of the triumph of amateurism.

Carson began to photograph when he was seven or eight years old. Photography has been a consistent part of his life, and over the past five years it has been a serious activity. He does not view himself as a frustrated photographer the way many graphic designers of the 1950s and 1960s viewed themselves as frustrated painters; rather, he sees photography as an extension of his activities as a designer. His camera is always at the ready. A decision to take a photograph is motivated solely by personal responses to things he sees without any ulterior motives or purposes. His camera gear is a small, moderately priced point-and-shoot 35mm camera; his darkroom is the one-hour processing shop around the corner.

Carson is the opposite of a large rotund man who took photography classes at the university where I teach. This guy lumbered down the hall, laden with ten-thousand dollars' worth of camera equipment. Three Nikons with intimidating lenses and two camera bags hung perpetually around his neck. While this portly camera porter made dull photographs, Carson produces engaging images with modest means.

In 1932, photographer Edward Weston explained: "**Man is the actual medium of expression, not the tool he elects to use as a means. Results alone should be appraised: the way in which these are achieved is of importance only to the maker. To the extent that the completed work realizes depth of understanding, uniqueness of viewpoint and vitality of presentation, will the spectator respond and participate in the original experience.**"[6]

It is not surprising to learn how deeply Carson has immersed himself in photography as an activity. "The designer", Lester Beall allegedly asserted, "is an eye traveling about the world, soaking up inspiration for use in his work."[7] When a designer who loves to travel and to photograph is invited to present lectures and workshops all over the world, the ultimate result is a body of photographs.

Carson's photographs fall into several general categories. Vernacular signs, graffiti, and homemade graphics fascinate him. Graphics made by peddlers and shopkeepers who can't afford the services of skilled sign-makers often achieve a vitality and originality, counteracting any crudeness or naivety and producing a rich lexicon of forms and spatial arrangements.

Kinetic images from Carson's television commercials and music videos take on a new identity when removed from time-based media and are re-presented on the printed page.

Non-objective compositions are another sphere of interest, but most of these were deleted as Carson struggled to edit over 260 pages down to a 192-page book. These include close-up shots whose subject matter can no longer be identified, video stills, and blurred images reduced to soft shapes and colors.

Many of the photographs in this book were made during Carson's extensive travels, but this is not a travel book. Tourists' photography is a large-scale business, as thousands return from vacations and order double sets of jumbo prints. Their view of the world is drivers' license photorealism; a straightforward click without attention to ideal time of day, camera angle, or the position of the primary light source. The Bermuda of the tourist photograph features family members posed in front of guide-book attractions. The vibrancy of the tourist brochure is seldom captured.

Travel photography seldom depicts travel. Carson observes and documents the travel process—looking out at airplane wings, drinking generic coffee on a bullet train, and the numbing anonymity of hotel rooms.

All of Carson's photographs fall into the category of the sensitive eye recording its experiences, with no particular motivation beyond the rapture of vision. One might almost call Carson a purist, for there is no agenda other than an unassuming directness of vision.

Unlike postmodern fine-art photographers who often present their work as detached documents, Carson presents his images as experiences to be shared. A photograph becomes a vehicle for encounters and confrontations. The first encounter occurs when the photographer, armed with a loaded camera, confronts the world and makes a decision to snap the shutter. The photograph then becomes a stored experience, waiting for new encounters with new viewers. Each viewer brings a unique vantage point, formed by personal experience, to the image.

Writing in *Camera Notes* in 1898, Sadakichi Hartmann wrote: "If I were asked, 'why does a man photograph?' I would answer: 'The average man photographs because life is so interesting to him that he would also like to show it to other people.'" Hartmann further noted: "In higher stages photography can reflect all the subtleties of a man's mind; then it is no longer a pastime, but the strenuous study of a lifetime."[8] Although I opened this section by calling Carson an amateur, I believe he has made the cut.

Edward Weston's 1932 statement for an exhibition of his photographs applies to Carson, and perhaps to many other artists, as well. Weston wrote: "**I have no unalterable theories to proclaim, no personal cause to champion, no symbolism to connote. Too often theories crystallize into academic dullness, bind one in a straitjacket of logic, of common, very common sense. To be directed or restrained by unyielding reason is to put doubt as a check on amazement, to question fresh horizons, and so hinder growth. It is essential to keep fluid by thinking rationally, by challenging apparent evidence and accepted ideas, especially one's own.**"[9]

Buenos Aires breakfast condiments assume a magical beauty through color infidelity.

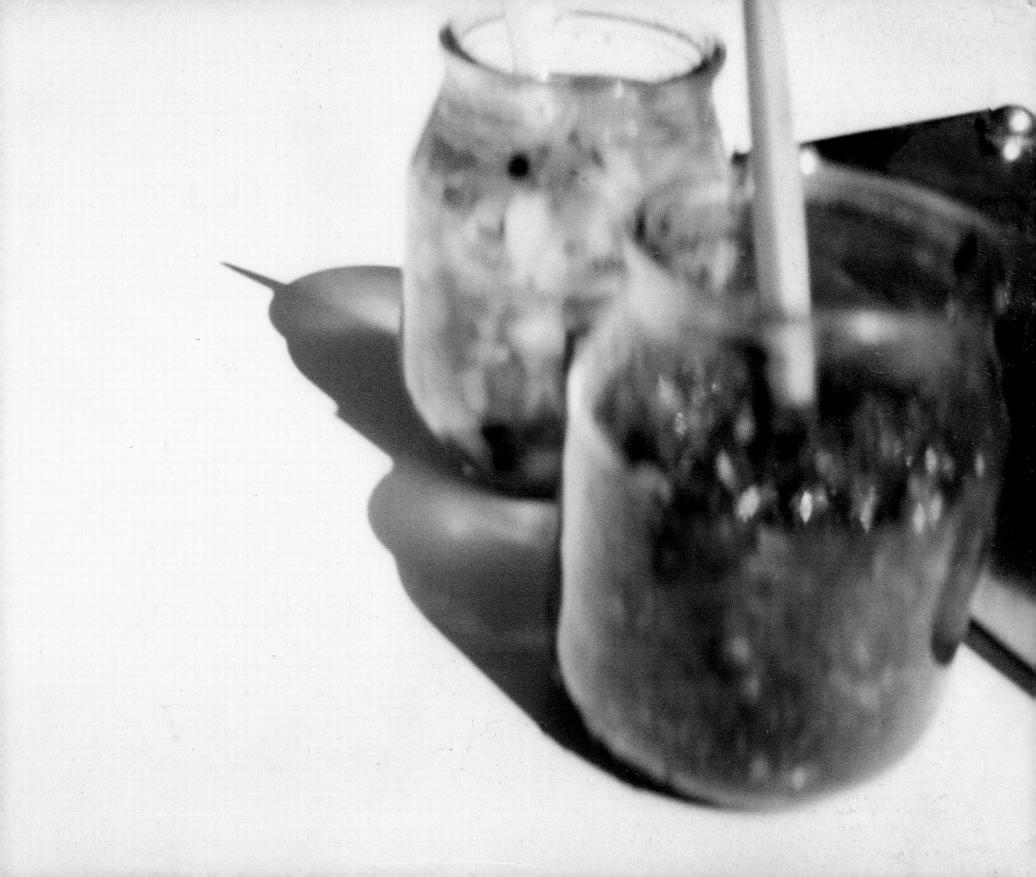

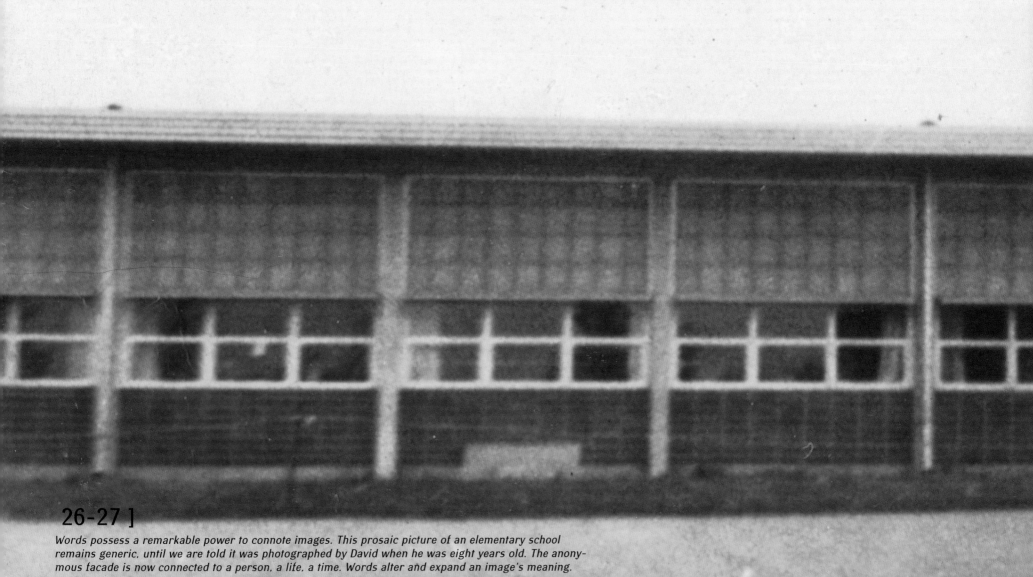

26-27]

Words possess a remarkable power to connote images. This prosaic picture of an elementary school
remains generic, until we are told it was photographed by David when he was eight years old. The anony-
mous facade is now connected to a person, a life, a time. Words alter and expand an image's meaning.

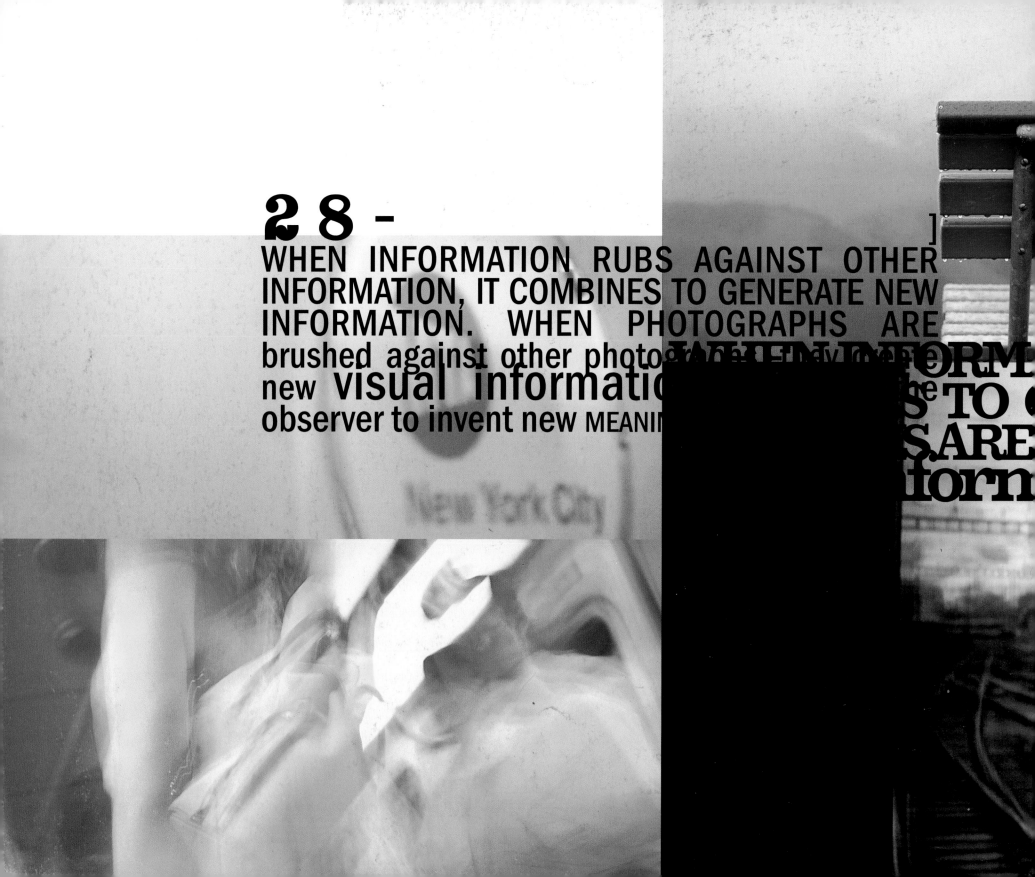

2 8 -

WHEN INFORMATION RUBS AGAINST OTHER INFORMATION, IT COMBINES TO GENERATE NEW INFORMATION. WHEN PHOTOGRAPHS ARE brushed against other photographs they invent new **visual information** observer to invent new MEANING

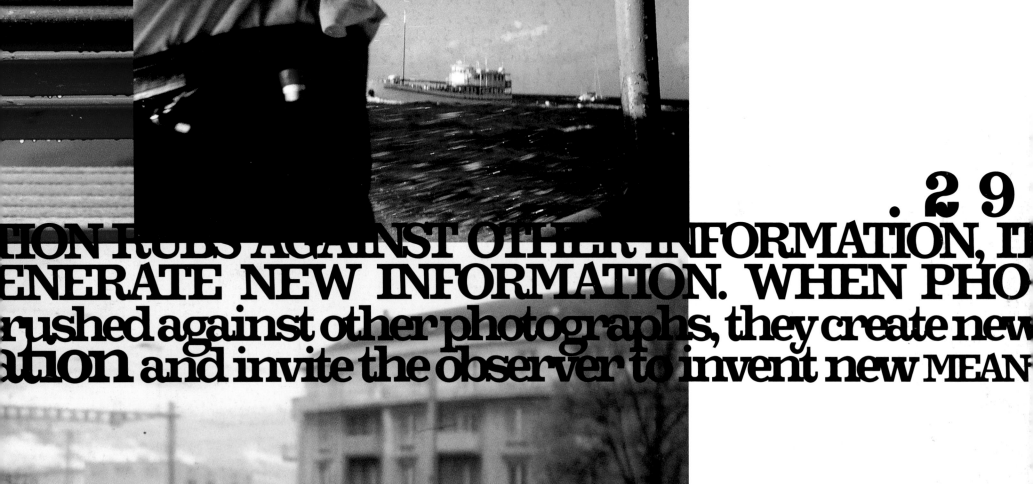

ION RUBS AGAINST OTHER INFORMATION, IT
ENERATE NEW INFORMATION. WHEN PHO
rushed against other photographs, they create new
ation and invite the observer to invent new MEAN

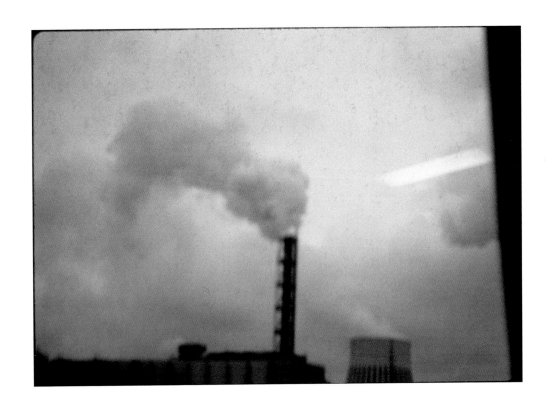

30-31]
Structures glimpsed from a train window can appear familiar or surreal. This occurs because they are either known and comfortable, or totally alien to one's past experience. The observer, not the structure, determines the response.

orange juice

[32-33]

Photo-minimalism. Close-up and out-of-focus photography permits the isolation of an attribute. The color of orange juice is isolated from its container; an omelette becomes a pattern of colors, experienced without interference. Food's chroma is as much a part of its identification and appeal as its aroma.

A street graphic in Austin, Texas, holds no meaning for us beyond its pictorial presence. Who is she? Why she is painted on newspaper applied to a window? And what she is eating? Pictures that do not clarify information become enigmas.

vegetarian omelette, tortola,august1998

The *Beach Culture* magazine sticker occupies seven tenths of one percent of the total area of this spread, but it commands our attention as the dominant form in the layout. Such is the power of intensely focused information in contrast to more general information. Viewers who know that David Carson came to prominence as the designer of *Beach Culture* magazine will have a different response to this photograph than those who do not have this background information.

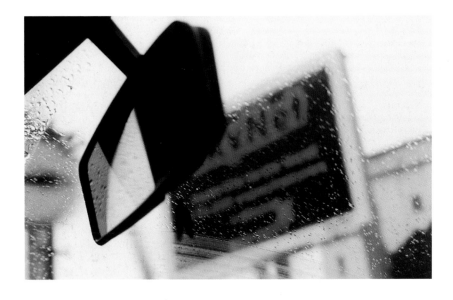

Chance meetings occur between people, and between forms in space. A camera in the company of an artist's eye is rarely available to record the moment when a rear-view mirror, a sign, and a building enter a rhythmic alignment as rare as a planetary array.

-37]

The vast emptiness of the sky, as seen from the confines of an airplane seat, becomes a metaphor for the suspended time of travel.

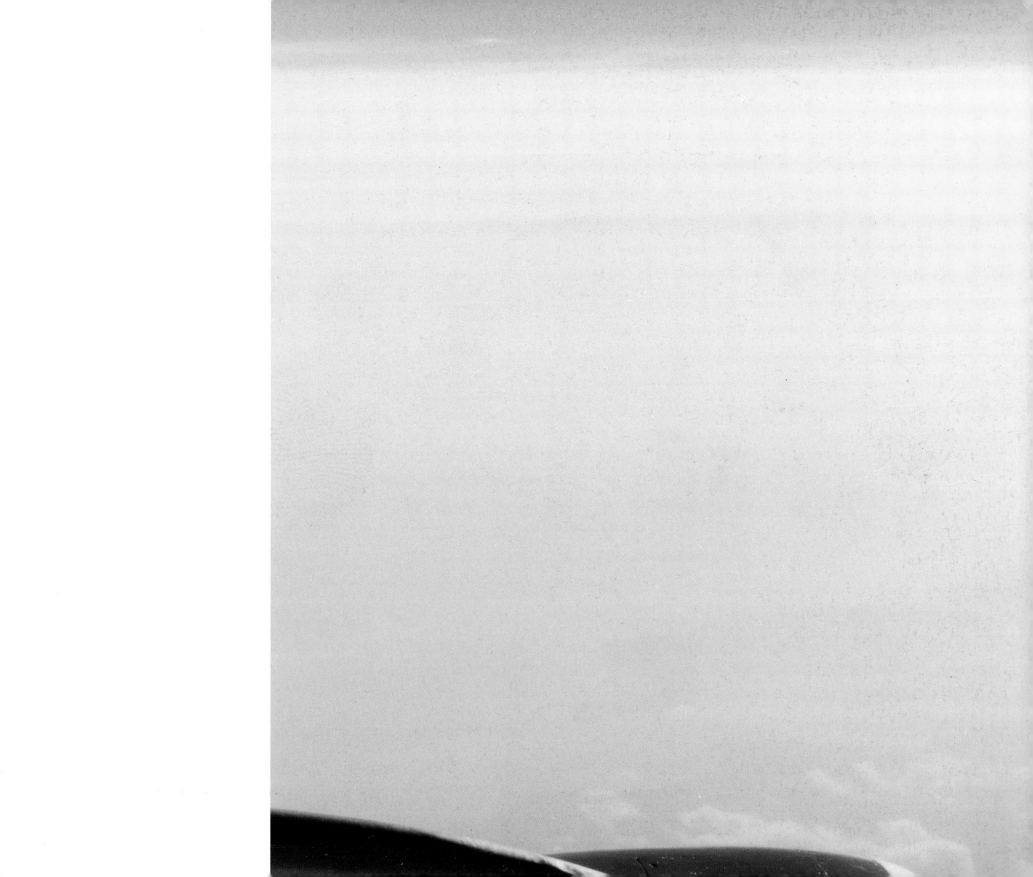

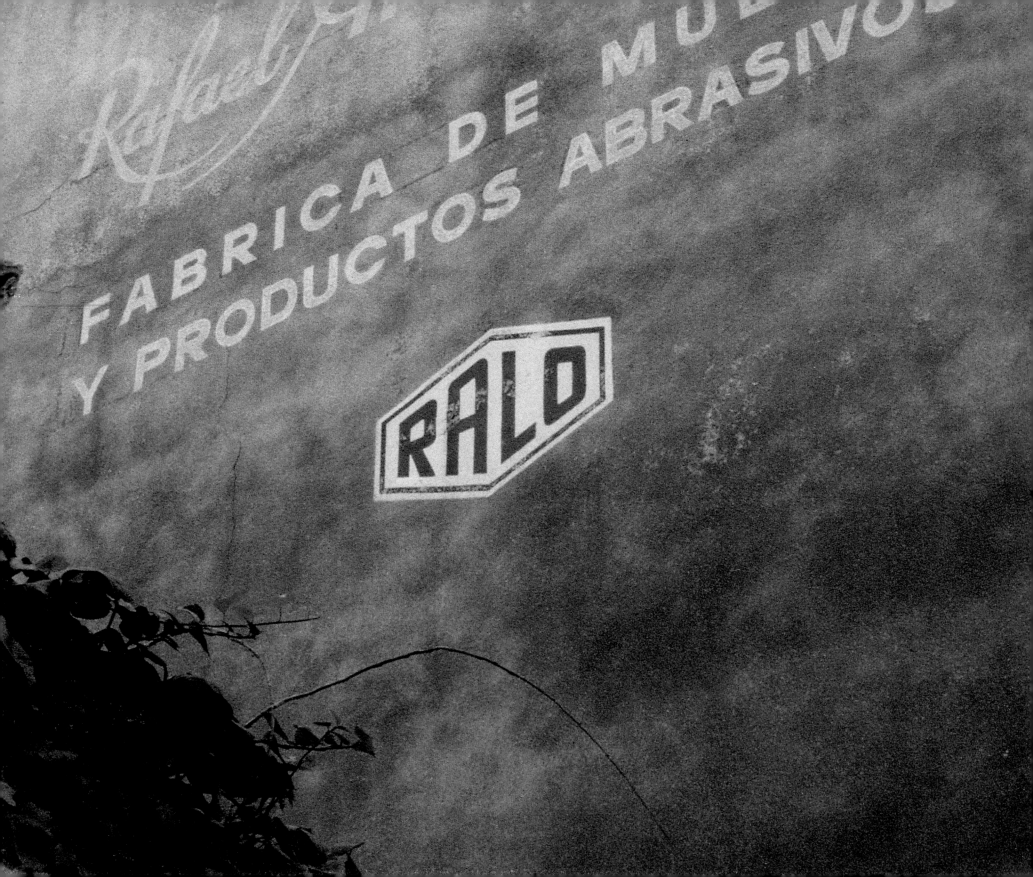

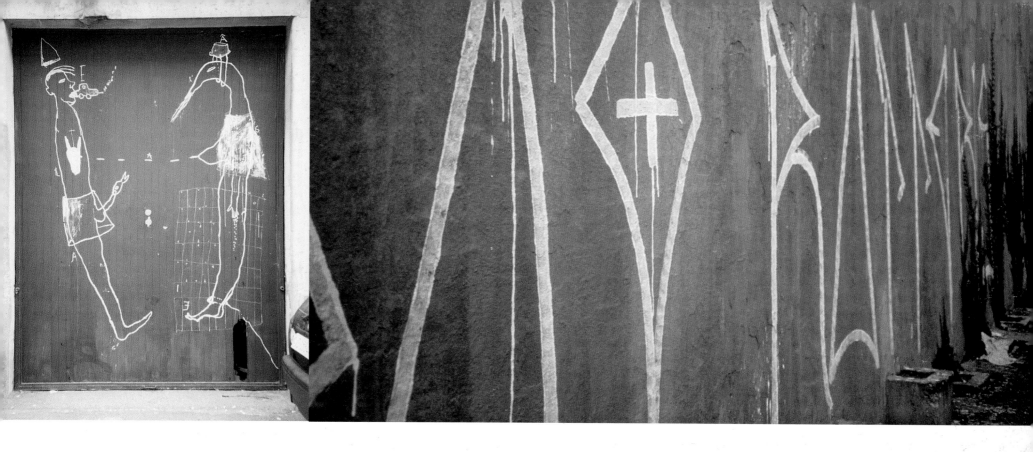

39

URBAN SIGNS REVEAL THE NATURE OF
THEIR CREATORS. TOP-DOWN MESSAGES FROM
ESTABLISHED ORGANIZATIONS JOSTLE WITH
BOTTOM-UP CLAMOR FROM THE PEOPLE.

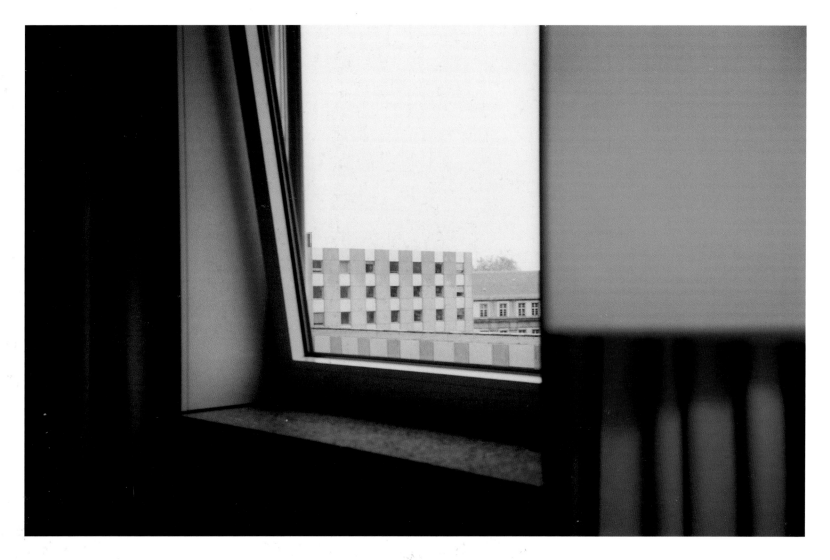

THE MATHEMATICAL PRECISION CHARACTERIZING CONTEMPORARY
ARCHITECTURE IMPOSES ORDER UPON CITY SPACES, PROVIDING
INSTANT COMPOSITIONAL STRUCTURES FOR THE PHOTOGRAPHER.
URBAN ENVIRONMENTS WITH A NUMBING SAMENESS DESPERATELY
NEED ORGANIC RELIEF.

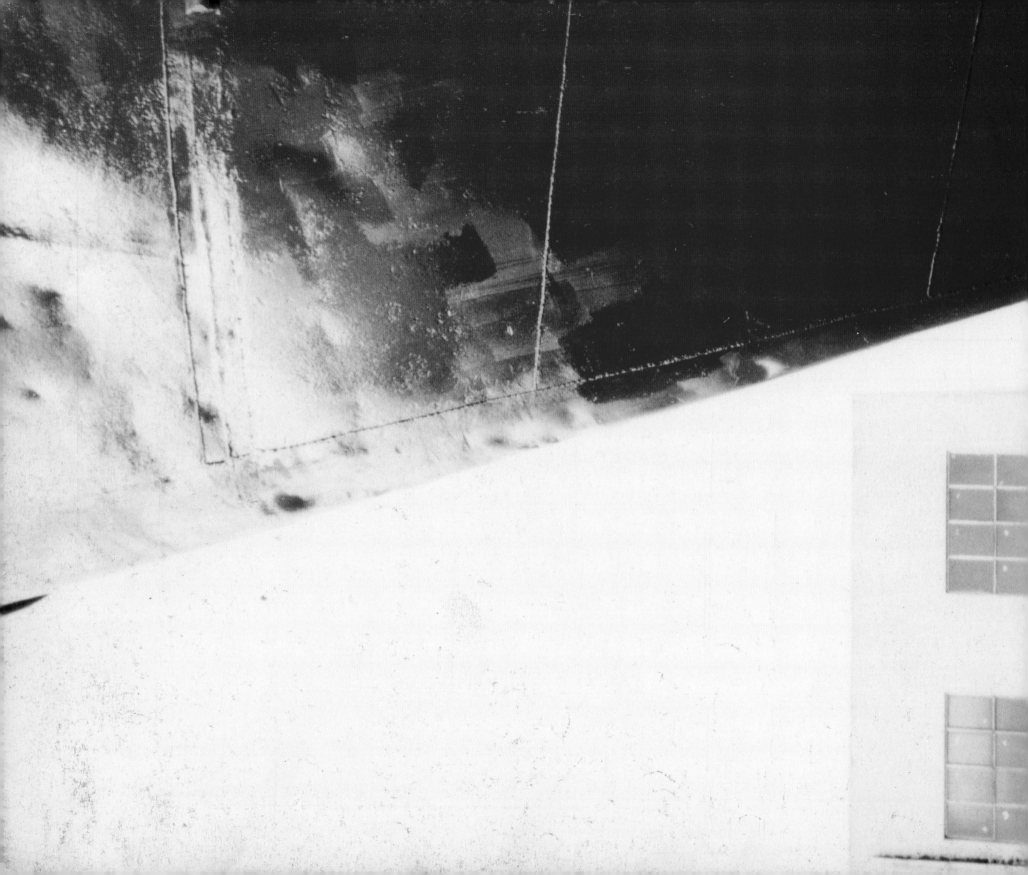

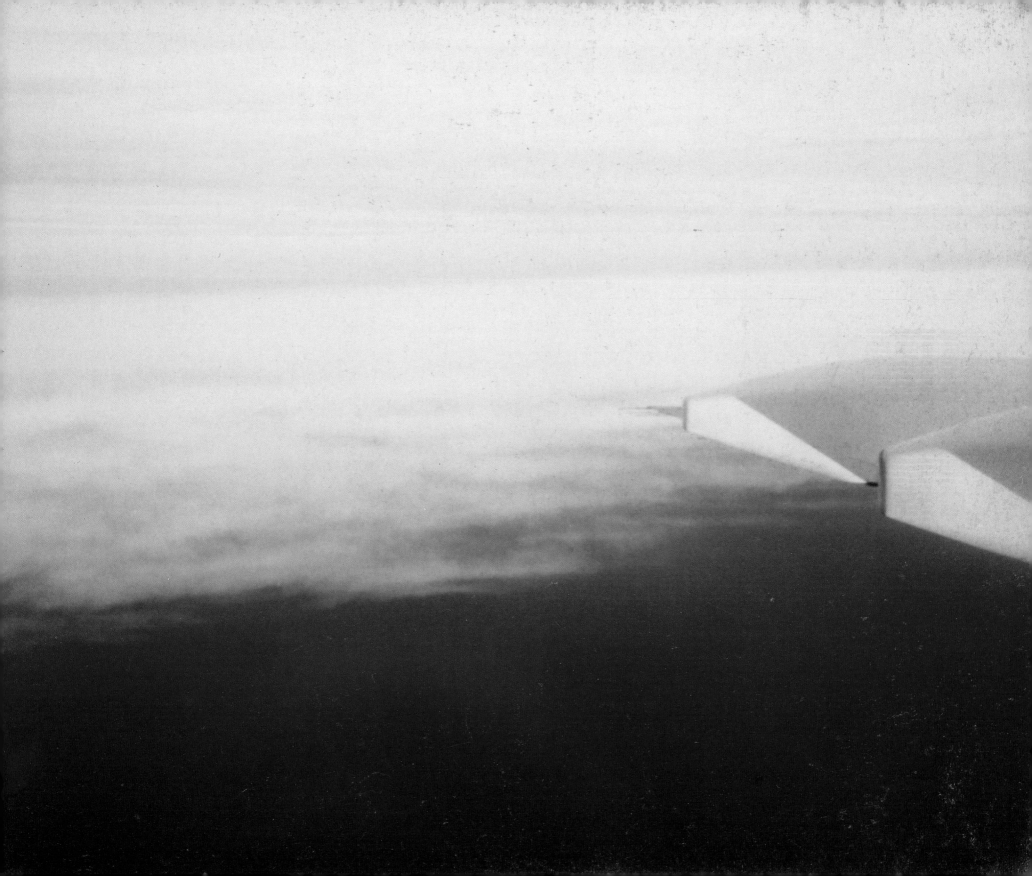

CHILE.

santiago

44 (45)

Human eyes—with their intense central focus that fades rapidly toward the peripheral vision—do not cope well with out-of-focus images. They scan and dart over the surface of the page, seeking detail. Blurred images force us to see overall color and mass, rather than detail.

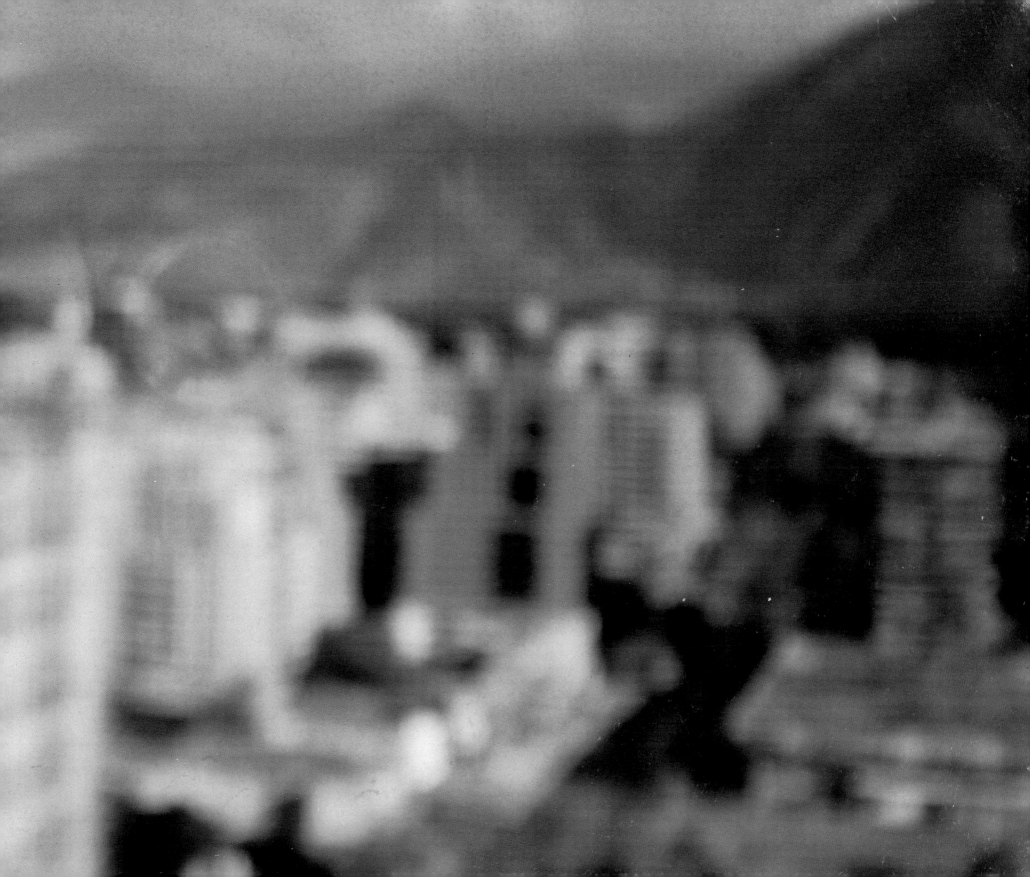

46.47]

PHOTOGRAPHS, like people, are inevitably altered by their companions. The juxtaposition of these two photographs causes us to see them in a different way from how we would see them if they were not companions.

DARK

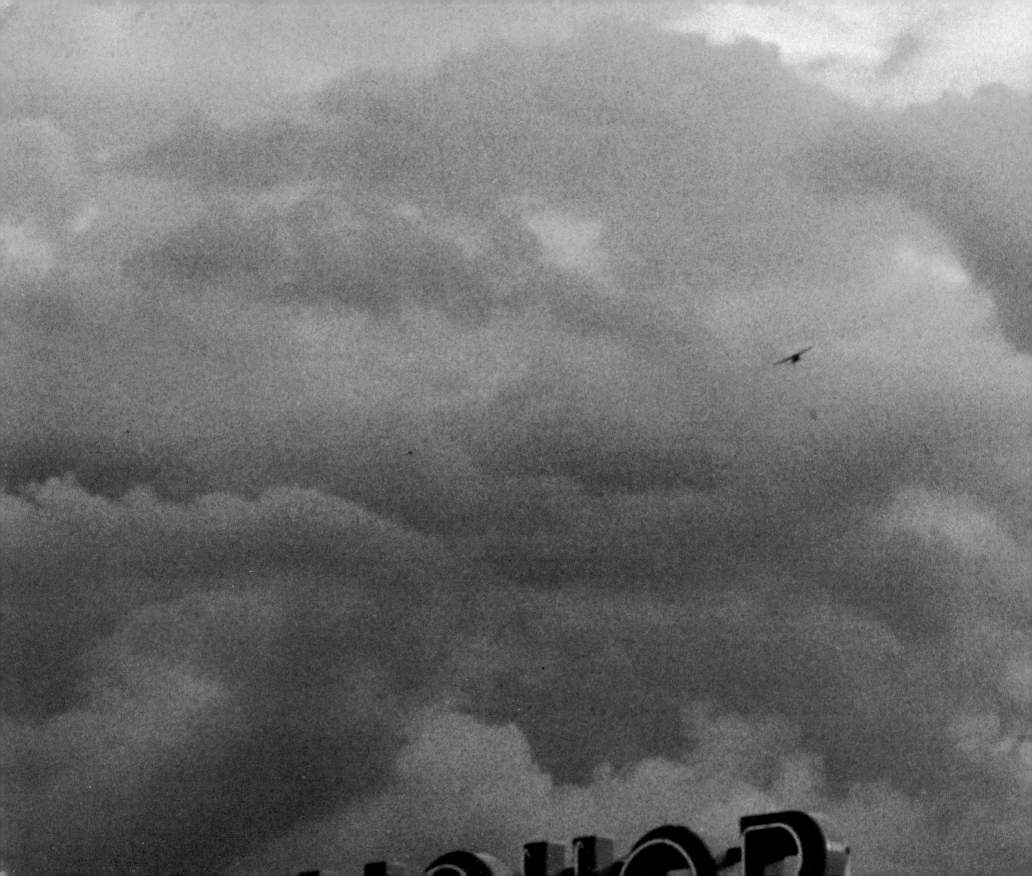

EVERY CAMERA STORE has a metal rack of books revealing the mysteries of taking good pictures. One learns to put the subject in the center, but not the dead center. They suggest dividing a photograph into nine equal rectangles, then placing the center of interest on one of the center rectangle's corners. I'm glad David never read these books.

5 0 . 5 l Leonardo understood
the power of the center and placed the
Mona Lisa and Christ in the dead center of his
masterworks. He was less compelled by the power of the corners
and edge, where complex subjects can have an interesting visual
dialog with the
frame and the
openness of the center.

GRANTS PASS

GRANTS PASS

"IT'S THE CLIMATE"

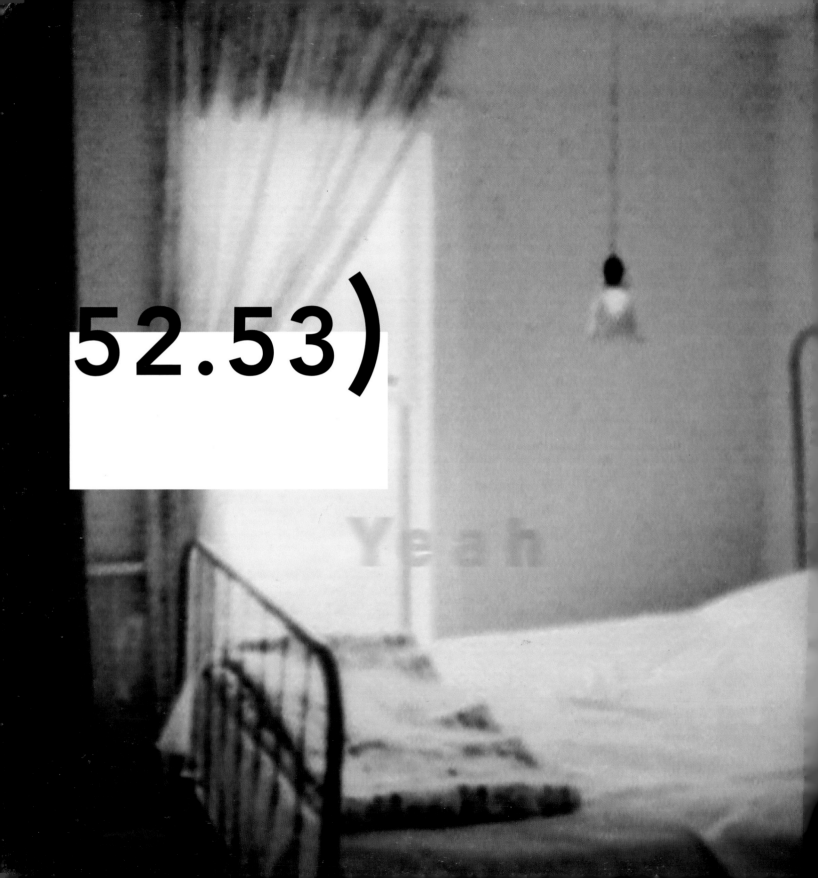

52.53)

FROM THIS DOBBS HOTEL ROOM IN WESTERN TEXAS, TO THE PLAZA HOTEL IN MANHATTAN, ROOMS FOR RENT MAKE STATEMENTS ABOUT THE HUMAN CONDITION, BUT THEY SELDOM GATHER EVIDENCE ABOUT THEIR OCCUPANTS THE WAY A PERSON'S BEDROOM DOES.

Yeah

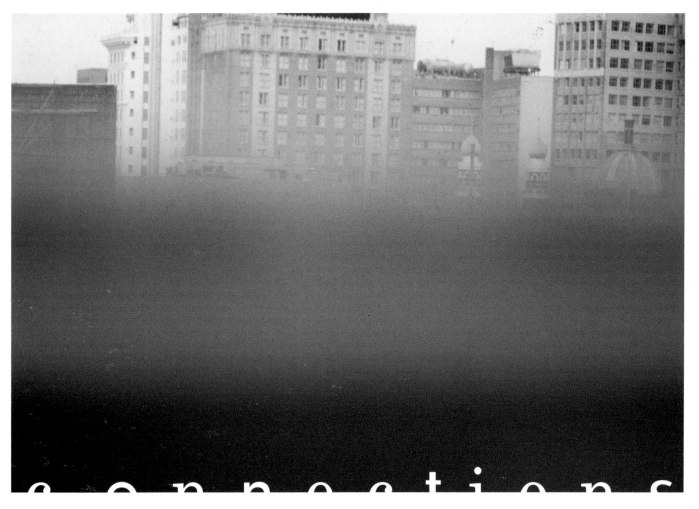

Connections. A city and a jungle are linked through horizontal alignment of their out-of-focus foregrounds. Proximity and alignment together create a presence more powerful than either image alone.

Horizontal spatial division, a time-honored tradition in Western art, developed from a passion with landscape art. It evokes our connectedness with nature.

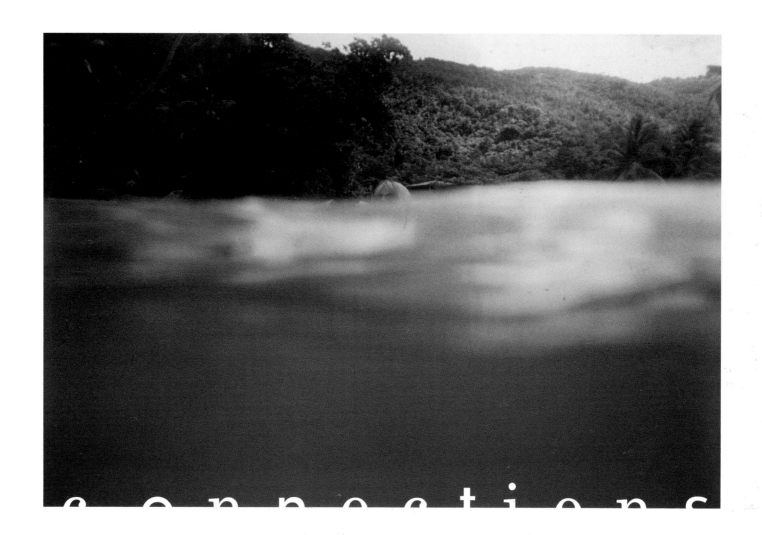

connections

comment.

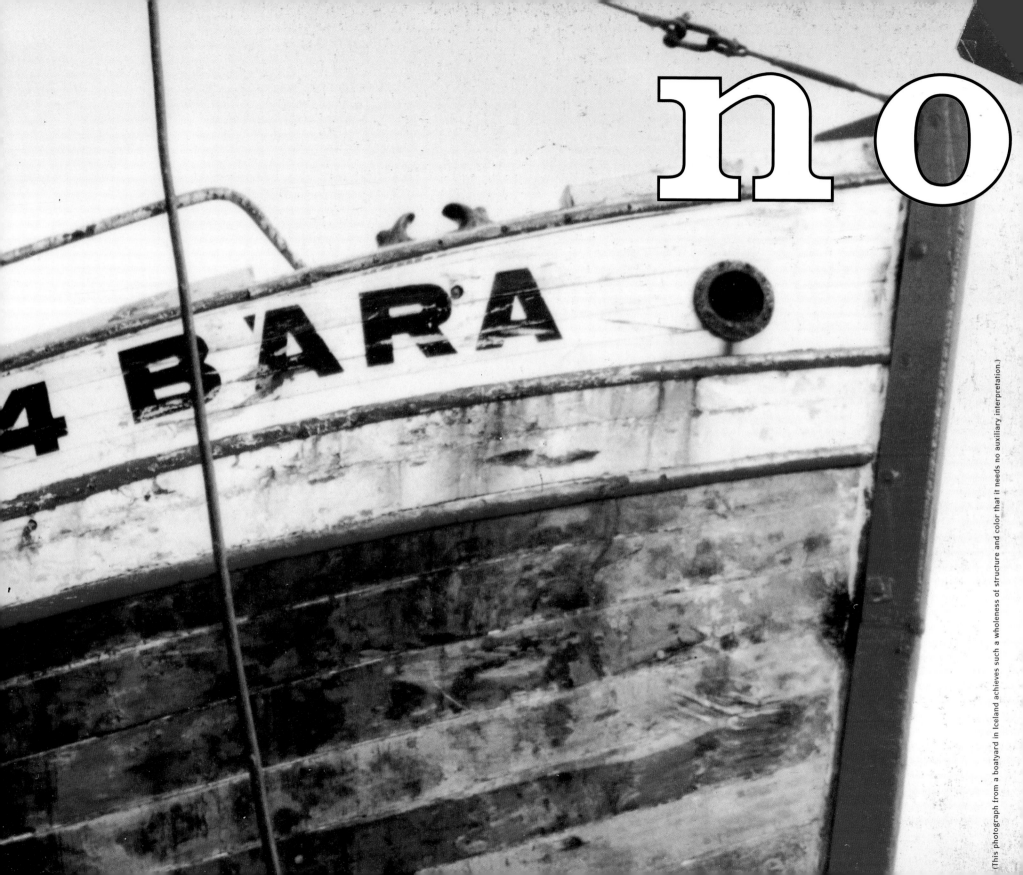

(This photograph from a boatyard in Iceland achieves such a wholeness of structure and color that it needs no auxiliary interpretation.)

58-59)

(LEFT
PHOTOGRAPHS WITH A VERY LOW LEVEL OF INFORMATION CAUSE US TO BE MORE AWARE OF THE VISUAL CHARACTER OF THE IMAGE. COLOR, SHAPE, AND SPACE COME TO THE FORE AS CONTENT RECEDES.

RIGHT)
GRAFFITI ISN'T JUST AN ASSAULT UPON A SIGN. IT IS AN ASSAULT ON A SOCIETY'S ESTABLISHED ORDER BY CITIZENS WHO FEEL DISENFRANCHISED. GRAFFITI IS THE SYMPTOM; ALIENATION IS THE DISEASE.
DC: JUST THE RIGHT AMOUNT OF GRAFFITI....THIS ALREADY WELL-DESIGNED SIGN IN ITALY GOT BETTER WITH THE HELP OF AN ANONYMOUS ARTIST.

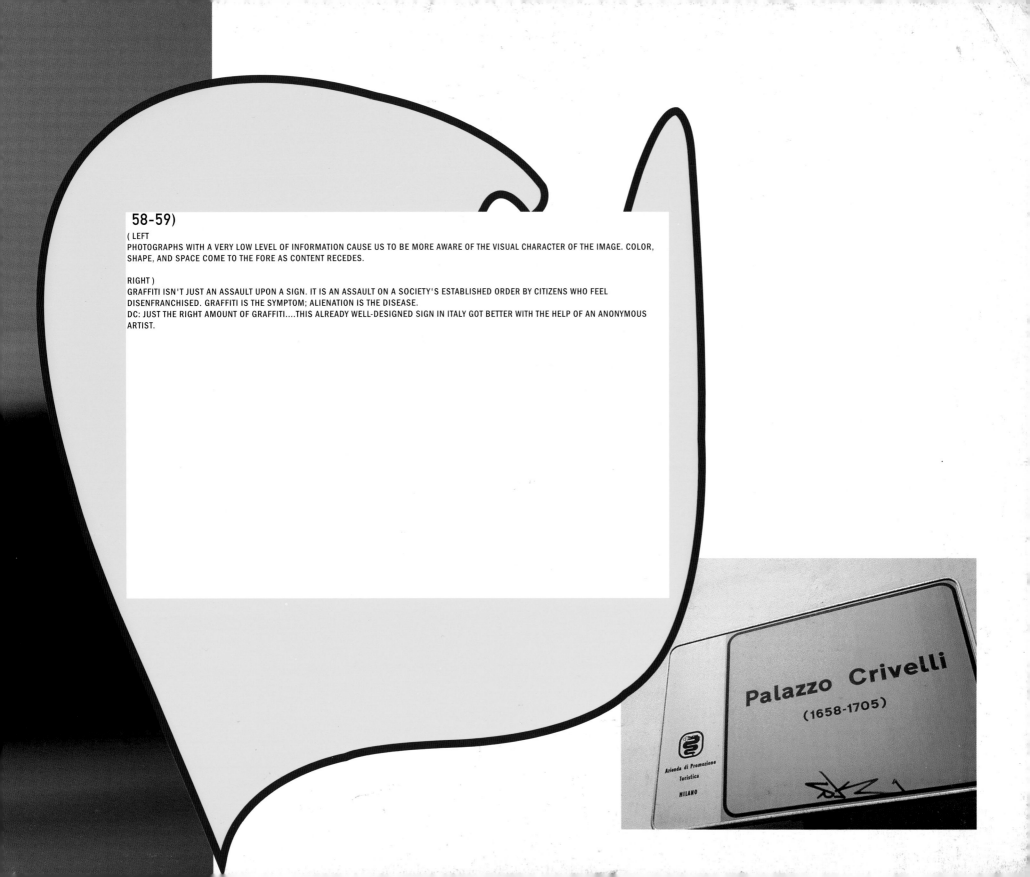

60.61]

[LEFT
PHOTOGRAPH TAKEN FROM THE CAR IN MILAN. THE NAKED WOMAN ON A BUS WOULD NOT RIDE AROUND AN AMERICAN CITY IN THIS WAY. HANDS ON THE BUS; HANDS IN THE BUS; THE VIEWER WHO NOTICES ALL THREE HANDS TRIES TO FORGE A RELATIONSHIP BETWEEN THEM.

RIGHT]
THIS PHOTOGRAPH DOES NOT HAVE A PROVENANCE OR HISTORY AS DAVID DOES NOT RECALL THE SUBJECT THAT YIELDED THE DETAIL. THE ELBOW-LIKE FORM AND RELATIONSHIP BETWEEN BUS CARD TYPE, THE WORD "MILANO", AND "OR TAVE" PRODUCE A COMPOSITIONAL RHYTHM THAT UNIFIES THE PAGES.

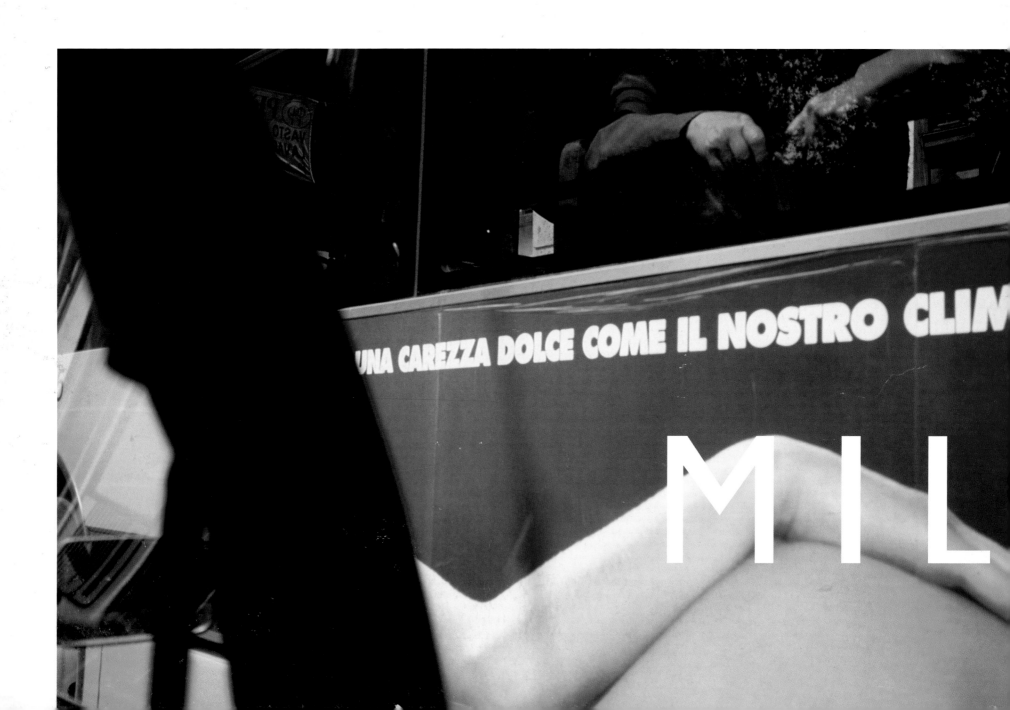

OR TAVE

ANO

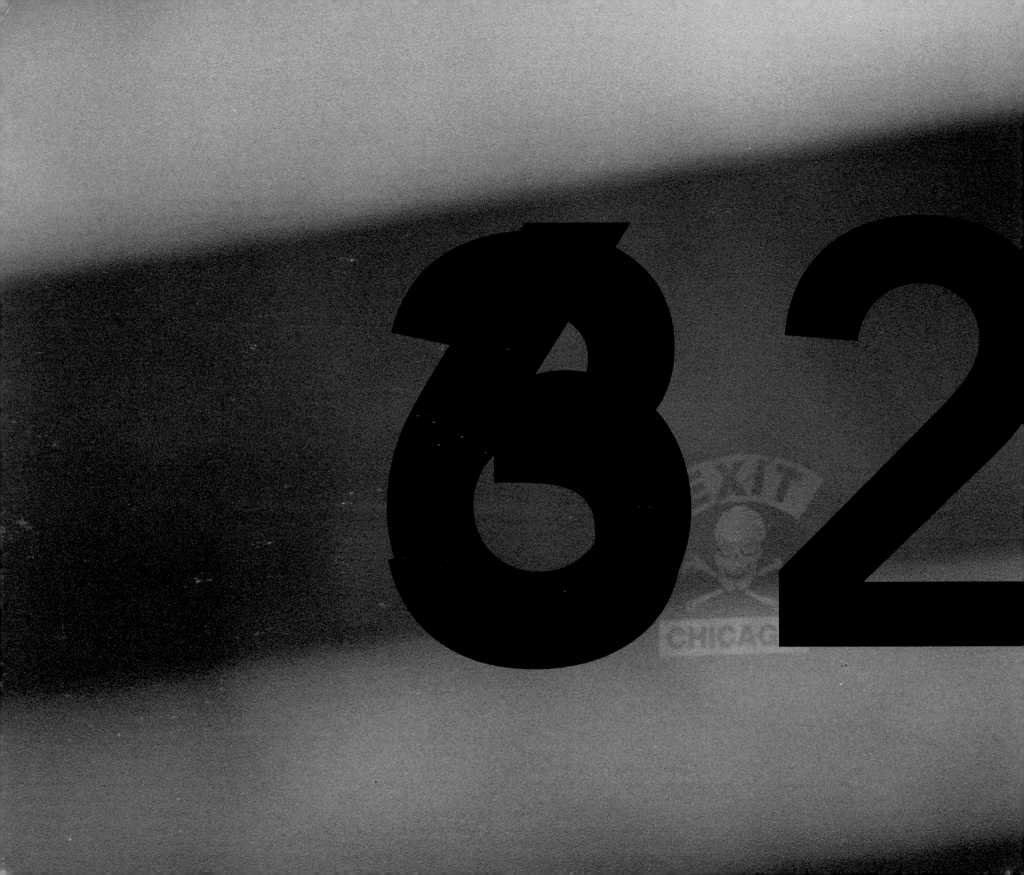

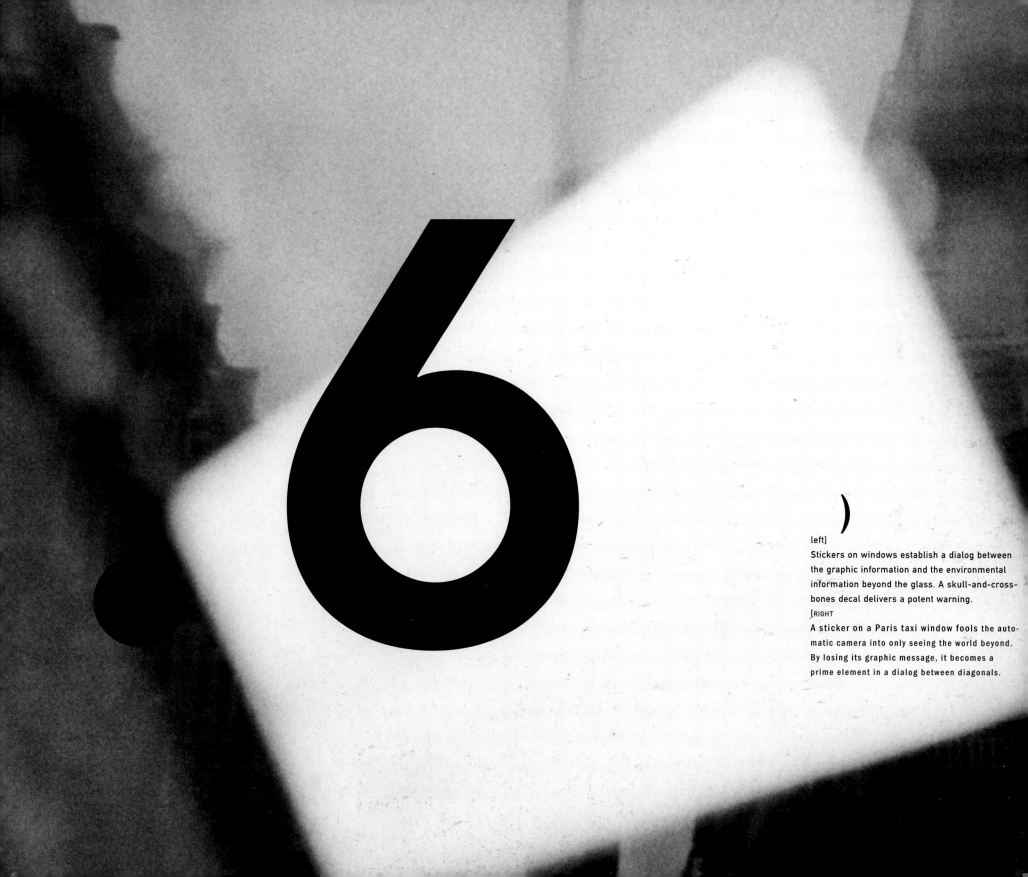

6

)

left]
Stickers on windows establish a dialog between
the graphic information and the environmental
information beyond the glass. A skull-and-cross-
bones decal delivers a potent warning.
[RIGHT
A sticker on a Paris taxi window fools the auto-
matic camera into only seeing the world beyond.
By losing its graphic message, it becomes a
prime element in a dialog between diagonals.

[left]
Close-ups and details convey a sense of place which may actually be radically different from the total environment.

Visual/verbal redundancy. When word and image indicate the same message, they abdicate their power to create a meaning bigger than the parts. Their interactive capacity falls mute.

This channel marker loses its sense of scale because no other object is around for comparison. One is free to imagine it as a large 6-foot sphere, or a small 6-inch one.

o6**6**.**6**₇**)**

In 1933, the eminent typeface designer FREDERIC GOUDY called
type "the leaden army that
conquers the world". A mere sixty-six years later, the "leaden
army" has been transformed into a
 pixilated band of luminous energy, circumnavigating the
earth. But the words—along with the sensory equipment of the
people who read them—haven't changed much.

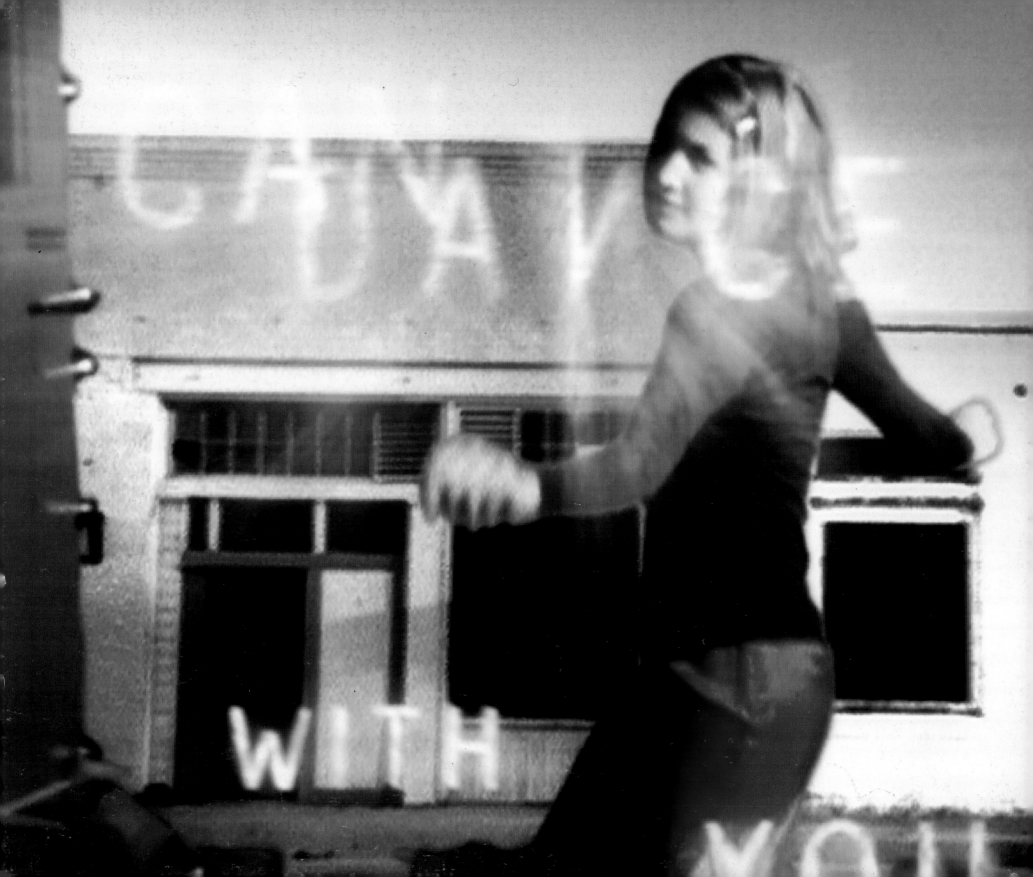

Kinetic media has invaded the printed page, changing the way type and image are used together. Controversy about new graphic design is one symptom of a vast generation gap between TYPOGRAPHIC1 and post-TYPOGRAPHIC2 people.

1 TYPOGRAPHIC PEOPLE: Those who developed their early communication skills from print media, and then learned electronic media.

2 POST-TYPOGRAPHIC PEOPLE: Those who developed their early communication skills from television and video games, and then learned to read.

6 8.6 9)

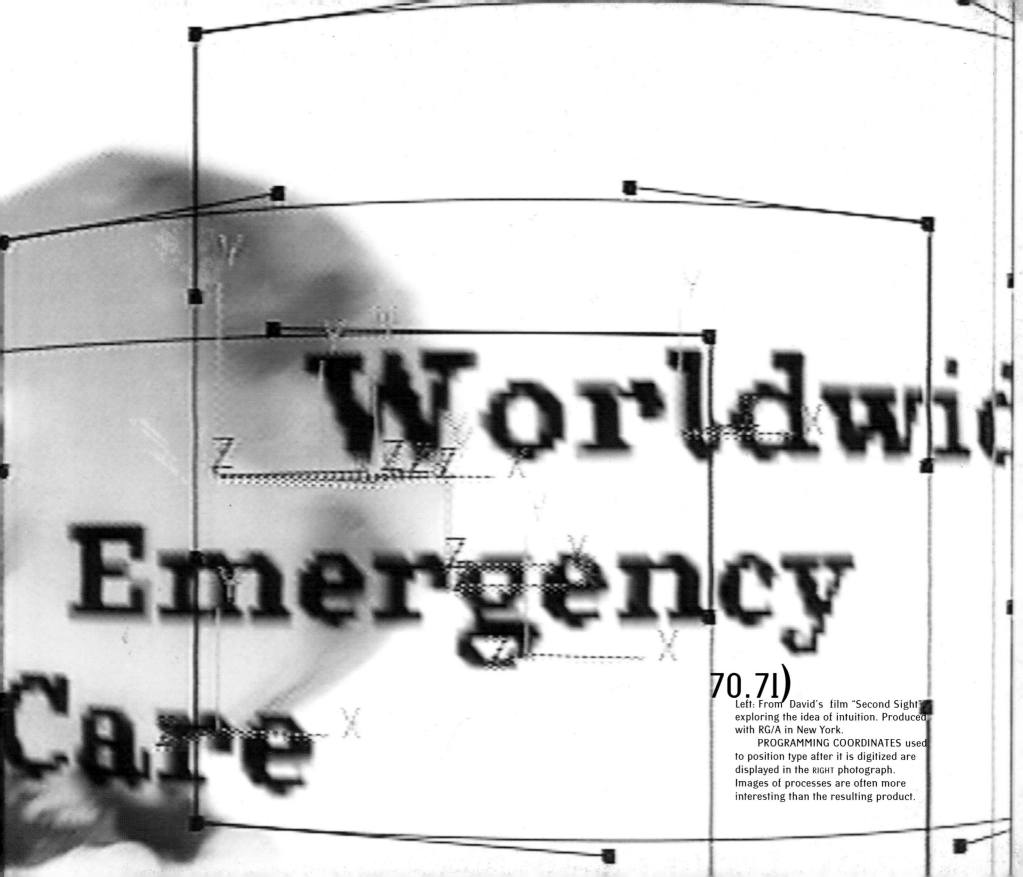

70.71)

Left: From David's film "Second Sight" exploring the idea of intuition. Produced with RG/A in New York.

PROGRAMMING COORDINATES used to position type after it is digitized are displayed in the RIGHT photograph. Images of processes are often more interesting than the resulting product.

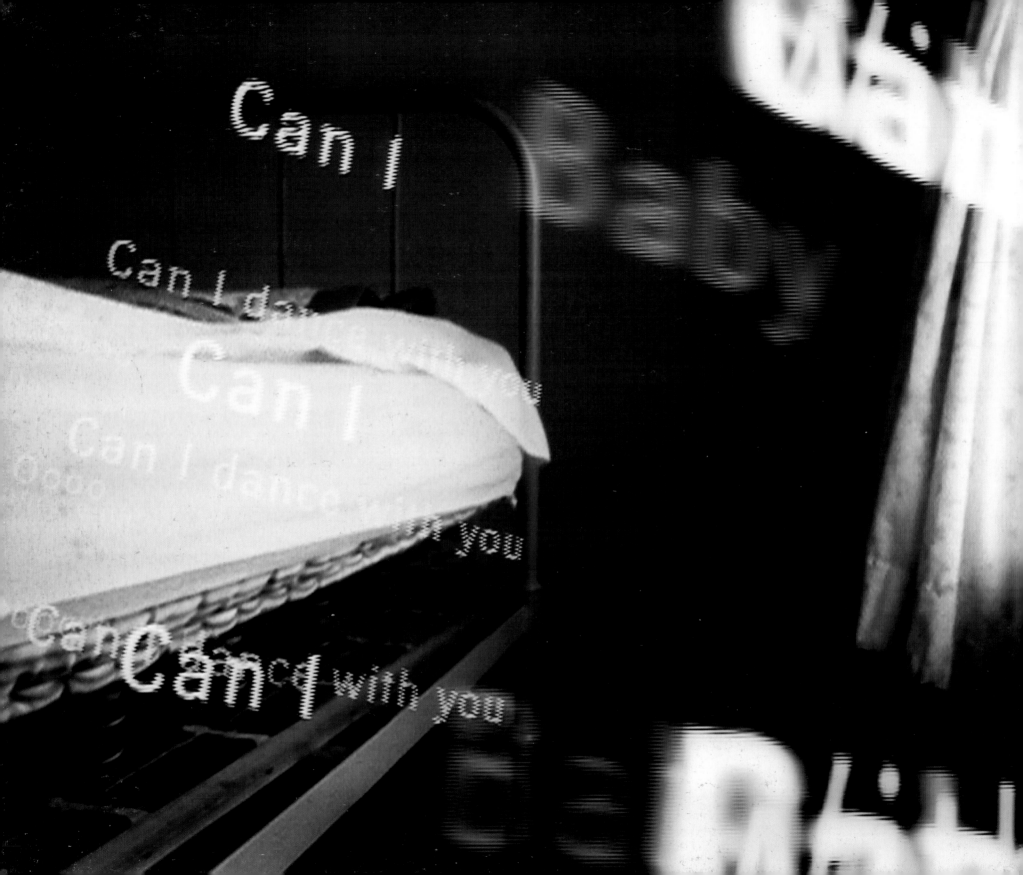

Axis Axis Axis Axis Axis Axis Axis

15 16 17

72.73]
A freeze-frame from the
"David Garza" music video
directed by Carson, stops
type in its tracks. Over the
course of the video the
type builds and builds and
builds. The Axis image is
from John Truck, the pro-
grammer's screen. It
displays forms
representing the axis of
individual typographic
elements and governs
their movement in space.

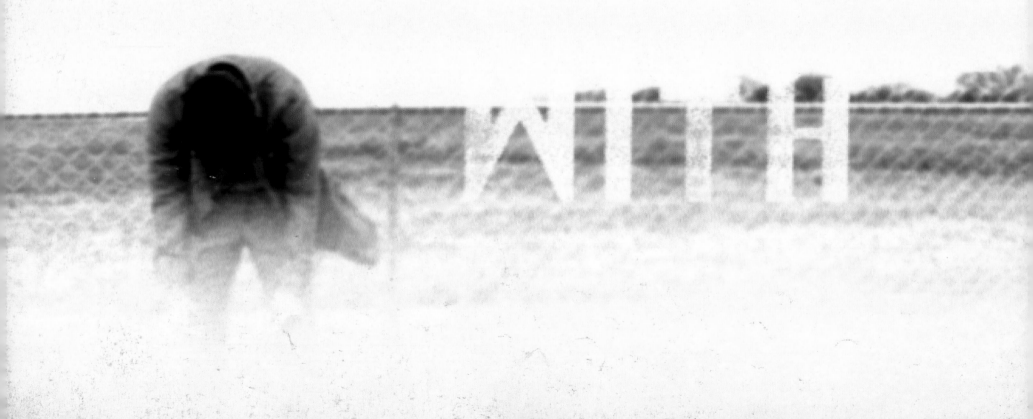

AN EYE FOR AN EAR: THE PRINTED PAGE CONVEYS THE RHYTHMIC CHANT OF CONTEMPORARY SONG.

DANCE
WITH

DANCE
WITH
YOU

Before I met you

Be

76 77

THESE SCREEN SHOTS FROM THE "DISCO BALL WORLD" MUSIC VIDEO PIXILATED
BECAUSE THEY WERE PLAYED AT HALF SPEED. THE STILL IMAGES TAKE ON A LIFE OF
THEIR OWN THAT IS DIFFERENT FROM THEIR PREVIOUS LIFE AS AN INSTANT IN A
SEAMLESS VIDEO SEQUENCE.

The kinetic image waits for nobody. Its subtle nuance flees our vision and
denies our memory. Rendered still, it becomes something it was never

meant

to

be.

we'd listen to the left side
of the radio

I used to know

Before I met you

listen to the left side

three eyes

I let you down

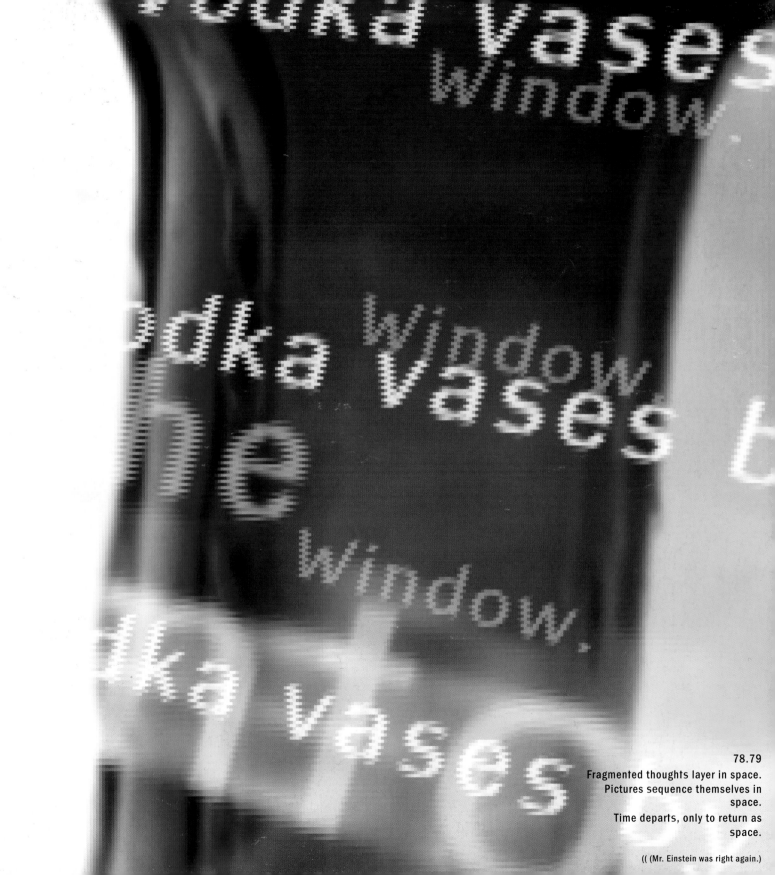

78.79
Fragmented thoughts layer in space.
Pictures sequence themselves in space.
Time departs, only to return as space.

((((Mr. Einstein was right again.)

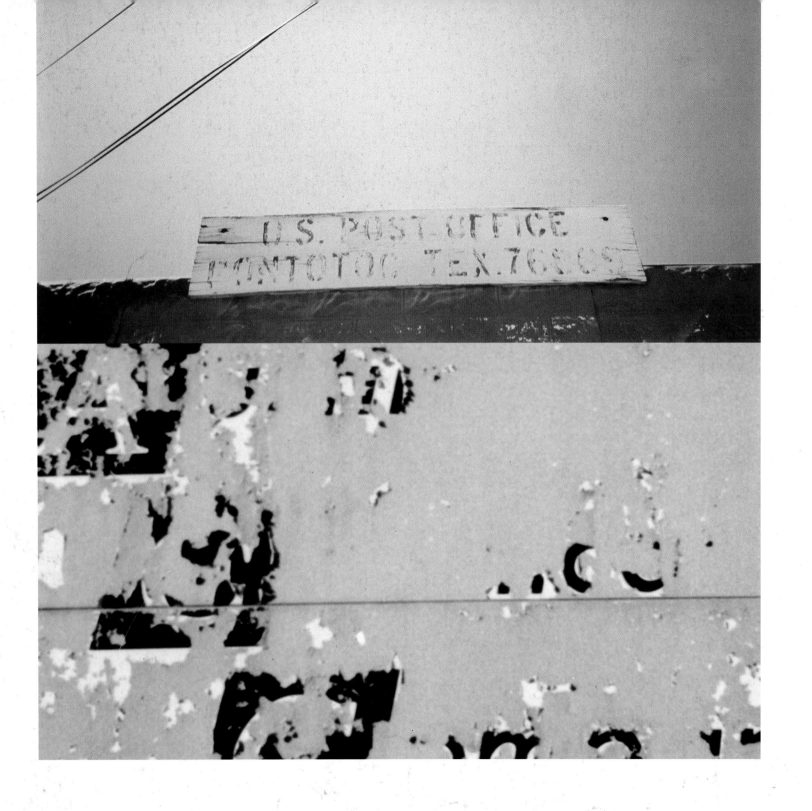

8o.81)

(CAPTION FOR POST OFFICE SIGN)
Although the sign conveys a feeling of abandonment, this post office is still in operation.

(CAPTION FOR CITY DOG OBEDIENCE SCHOOL)
Sometimes ignorance is bliss; at other times it is freedom. Unschooled in proper letter spacing, this sign's maker was free to invent a new spatial syntax.

(CAPTION FOR DECAYING BILLBOARDS)
As they decay, billboards become more interesting than they were when fresh and new. This tells us something important about the state of billboard art.

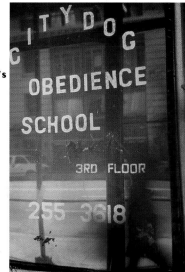

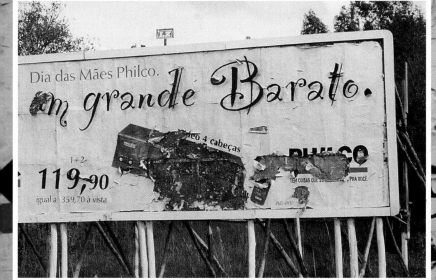

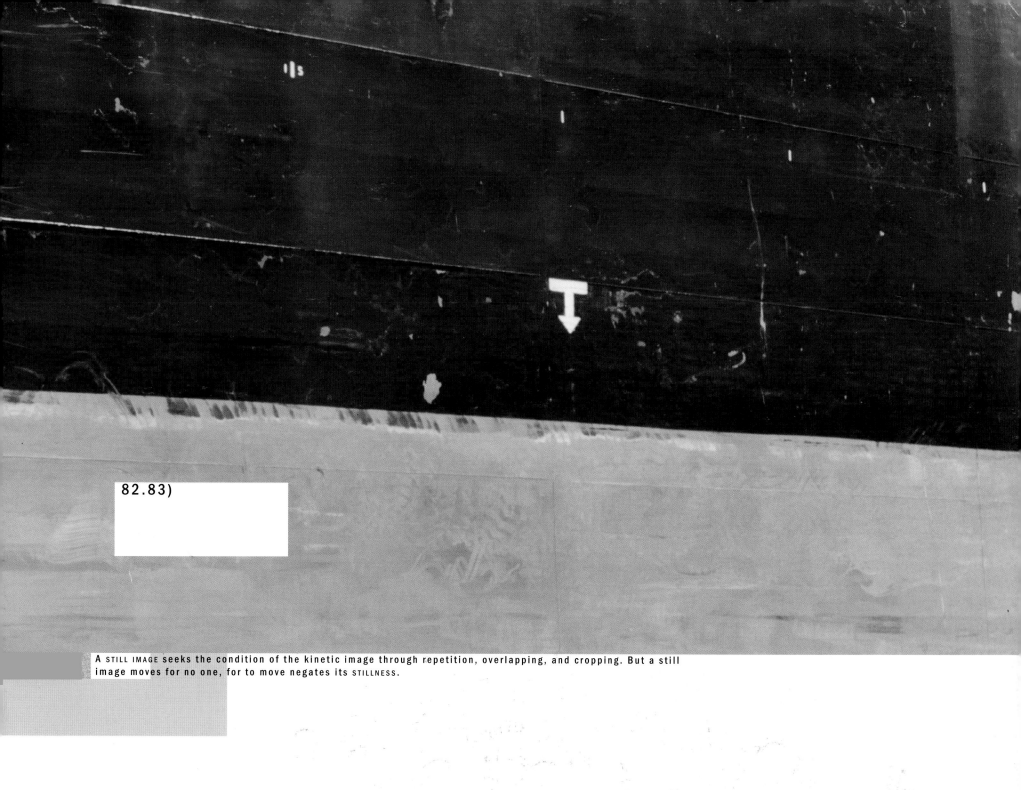

82.83)

A STILL IMAGE seeks the condition of the kinetic image through repetition, overlapping, and cropping. But a still image moves for no one, for to move negates its STILLNESS.

84) COMMON SUBJECTS REQUIRE UNCOMMON PHOTOGRAPHY.
UNCOMMON SUBJECTS REQUIRE COMMON PHOTOGRAPHY.

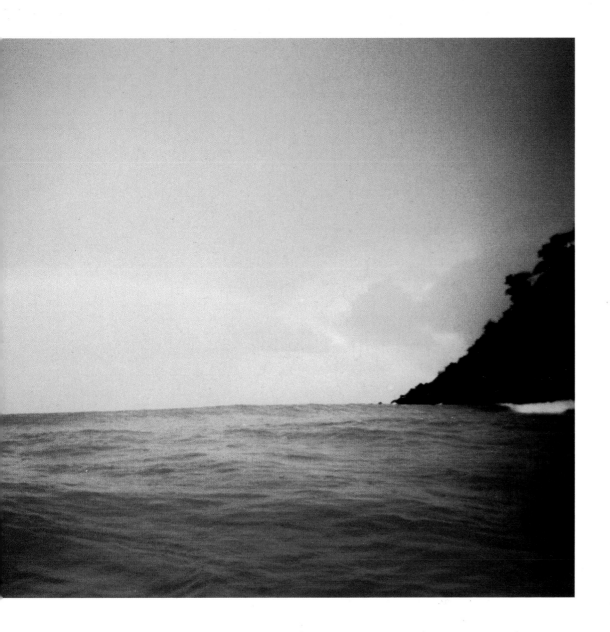

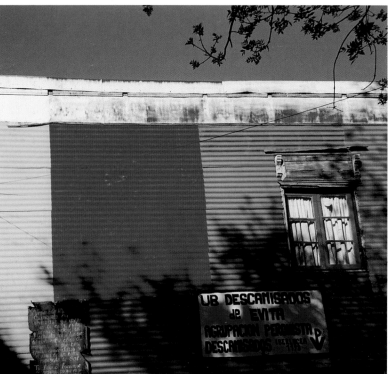

OBJECTS AND ENVIRONMENTS collect evidence. Over time they reflect the presence of people, animals, and natural forces. A recycled shipping box or a posting wall acquire an aesthetic life from chance occurrences. A box or wall waits for the arrival of the photographer, whose vision recognizes and documents the phenomena.

MARCEL DUCHAMP'S found objects, declared to be art and exhibited as sculpture, come to mind here. The world is a vast aesthetic mindfield (I do mean mindfield, not minefield) of photographic possibilities.

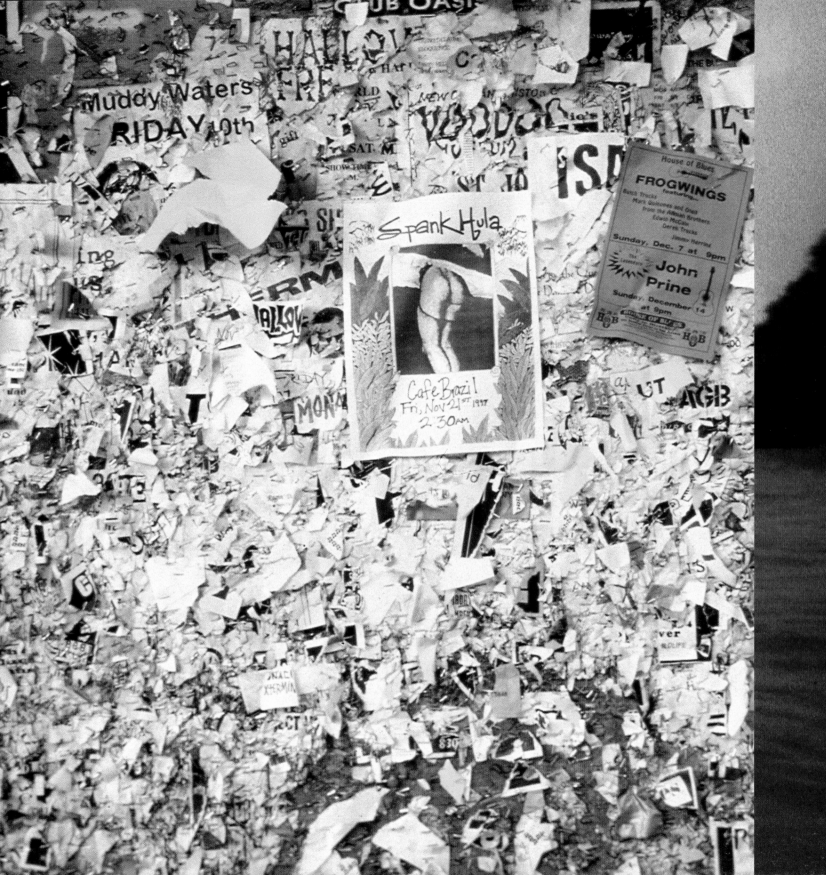

Simple visu-
al themes,
such as
black spots
on light
opposite
light spots
on black,
delight the
mind and
excite the
eye.
(David's per-
sonal col-
lage work.)
"Give us a
call." This
proves how
resilient
alphabetical
messages
are to
entropy and
degrada-
tion.

092 - 093)

*

Earlier I commented on the power of words to shape the meaning of an image. An image can sometimes shape the meaning of words as well. Substitute a photograph of a diaper for one of lace underwear, and the word BABY heads in a wholly different direction.

*

While traveling and painting in Tunis in 1914, Paul Klee wrote: "Color has taken hold of me; no longer do I have to chase after it. I know that it has hold of me forever. That is the significance of this blessed moment. Color and I are one."[1] Children are at one with color, but, in many industrial societies, lose this blessed gift to age.

"No color is conceivable without form and no form without color," wrote Karl Gerstner. "Conversely, any color can be pictured in any form and any form in any color. Form is the body of color and color the soul of form."[2]
 Icelanders understand this very well.

1 Quoted by Will Grohmann in Paul Klee, New York 1954, p. 57.
2 Karl Gerstner, The Forms of Color, Cambridge, MA 1986, p. 8.

wig factory in rome

8 5)

IN AUSTIN, TEXAS, PEOPLE GATHER ON THE CONGRESS AVENUE BRIDGE AT TWILIGHT
EVERY EVENING TO WATCH THOUSANDS OF BATS FLY OUT OF THE LARGEST KNOWN URBAN
BAT COLONY IN THE WORLD, CONTAINING NEARLY 1.5 MILLION MEXICAN FREETAIL BATS.

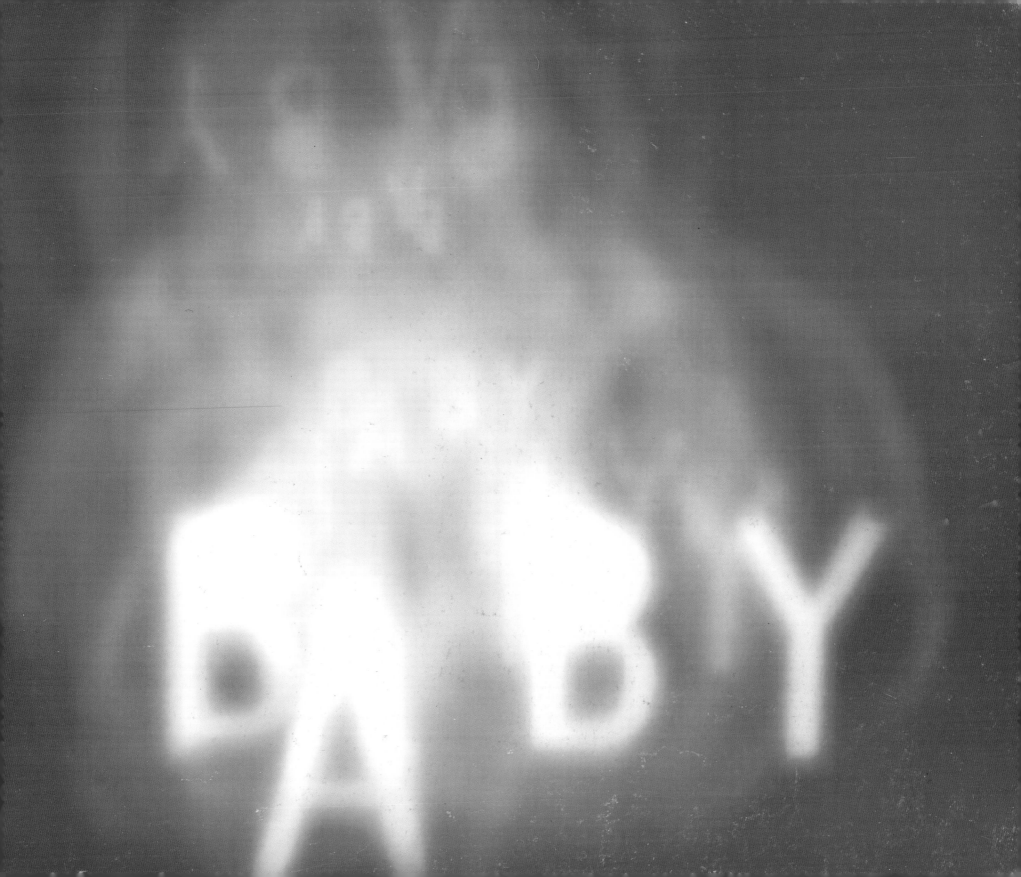

At the David Carson
exhibition in Düsseldorf,
huge transparent enlarge-
ments of spreads from
Raygun magazine hung in
the galleries. Visitors
walking through the
space appeared to be
elements in the layouts.
The audience became
components of the art:
the glare from the camera
flash became part of the
photography documenting
the opening.

96-97

david bowie

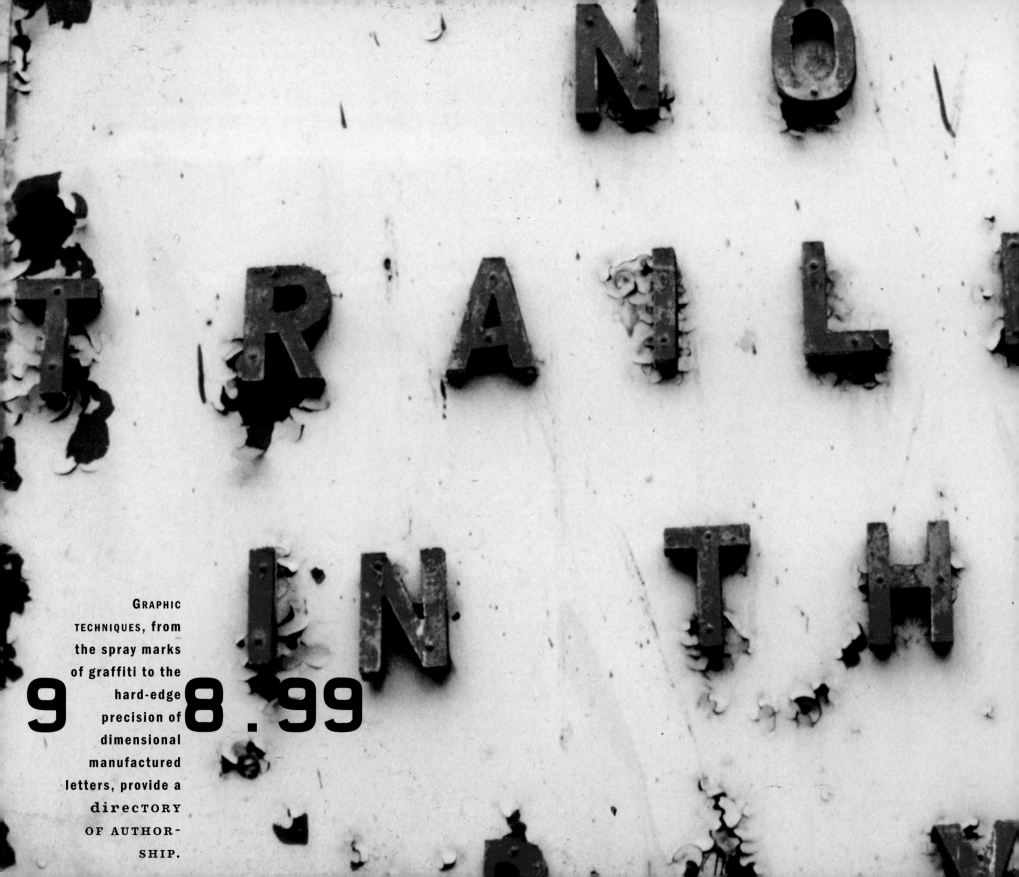

GRAPHIC TECHNIQUES, from the spray marks of graffiti to the hard-edge precision of dimensional manufactured letters, provide a directory OF AUTHOR- SHIP.

9 8.99

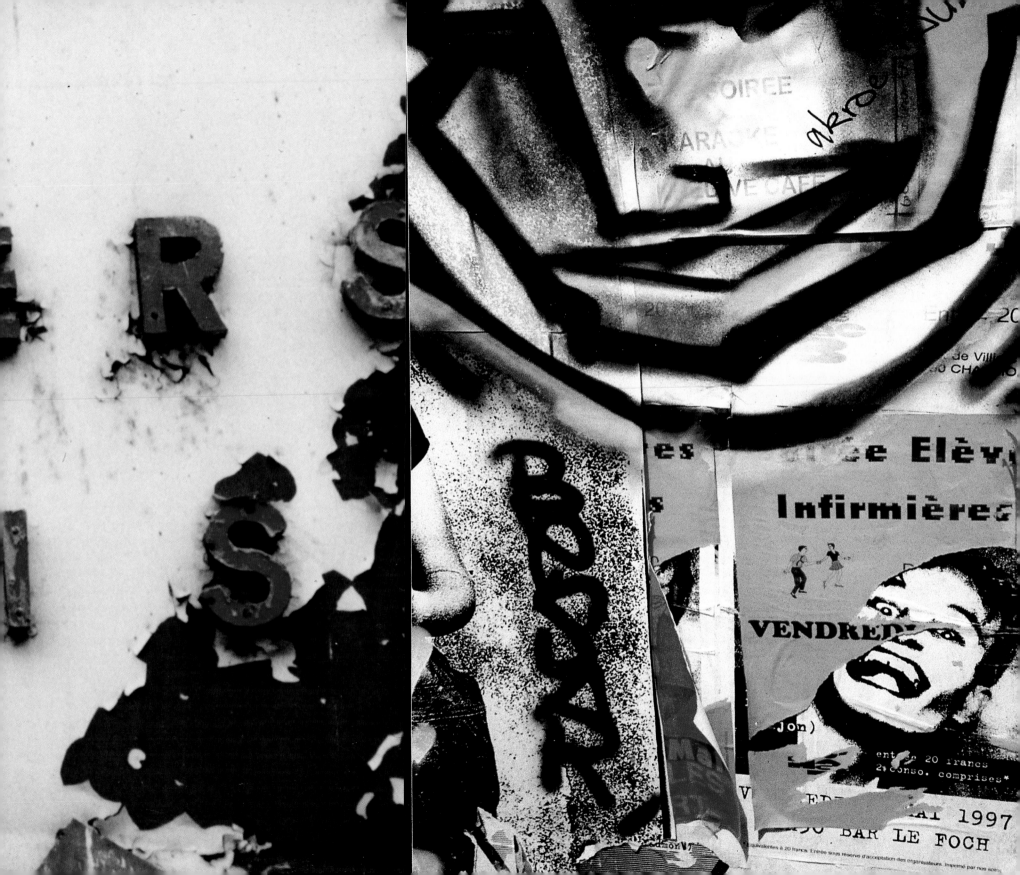

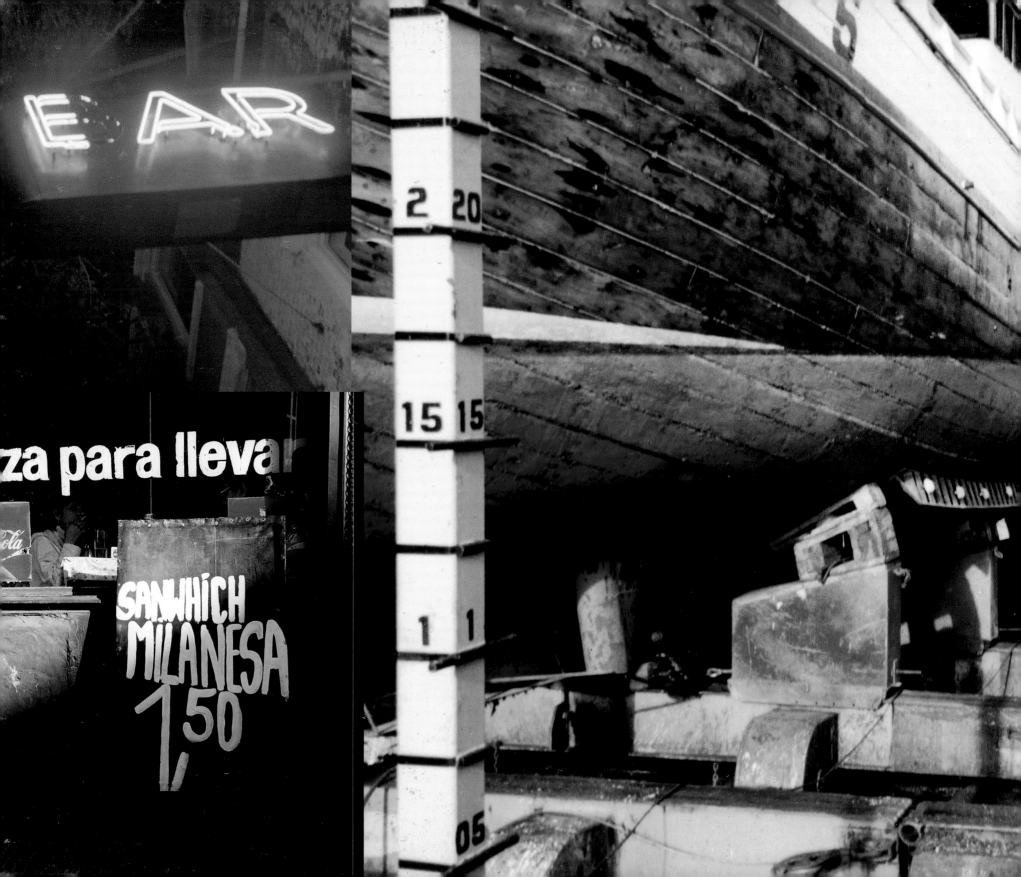

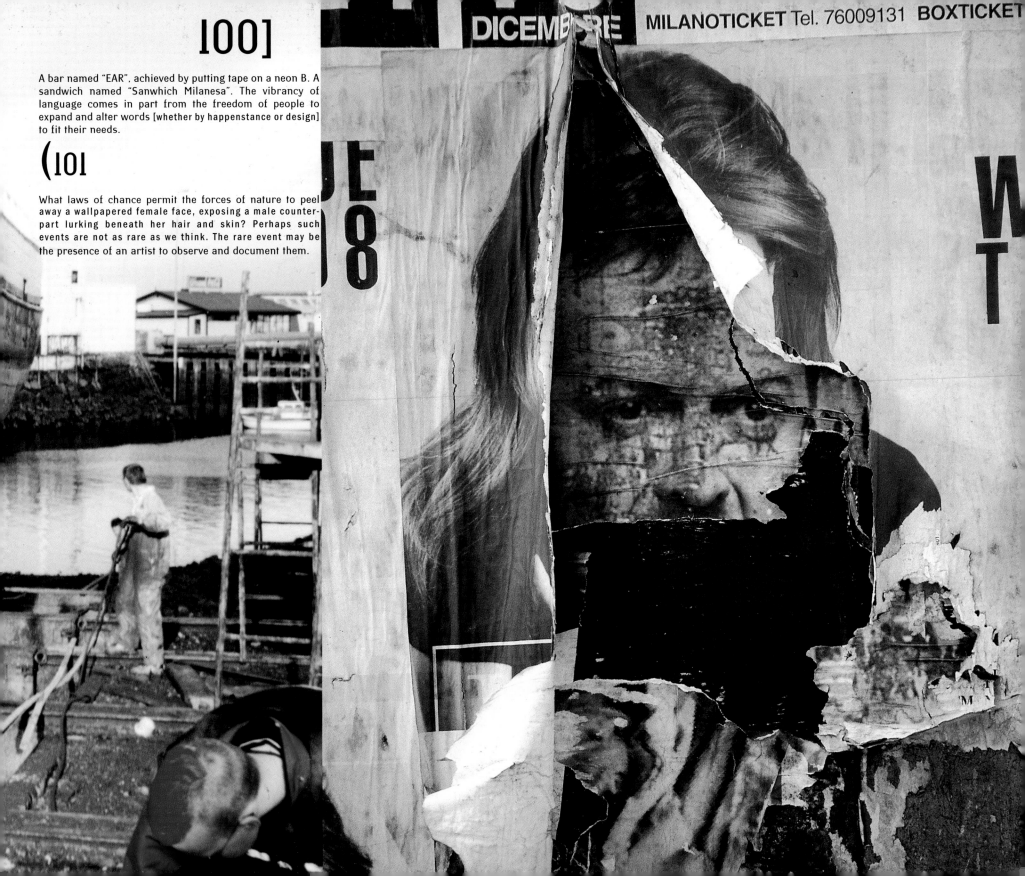

[OO]

A bar named "EAR", achieved by putting tape on a neon B. A sandwich named "Sanwhich Milanesa". The vibrancy of language comes in part from the freedom of people to expand and alter words [whether by happenstance or design] to fit their needs.

(IOI

What laws of chance permit the forces of nature to peel away a wallpapered female face, exposing a male counterpart lurking beneath her hair and skin? Perhaps such events are not as rare as we think. The rare event may be the presence of an artist to observe and document them.

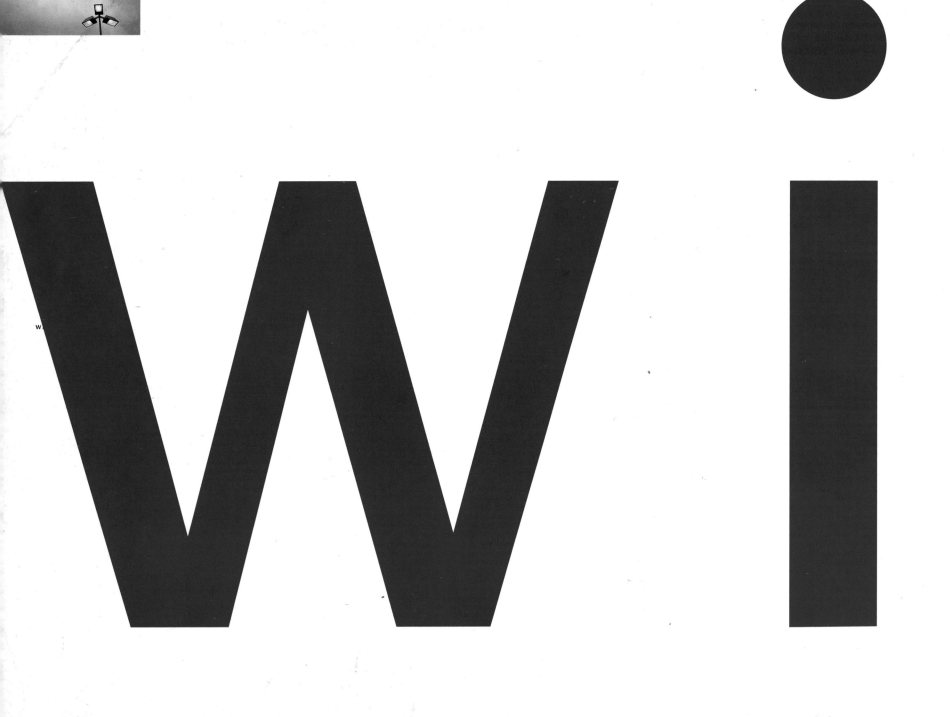

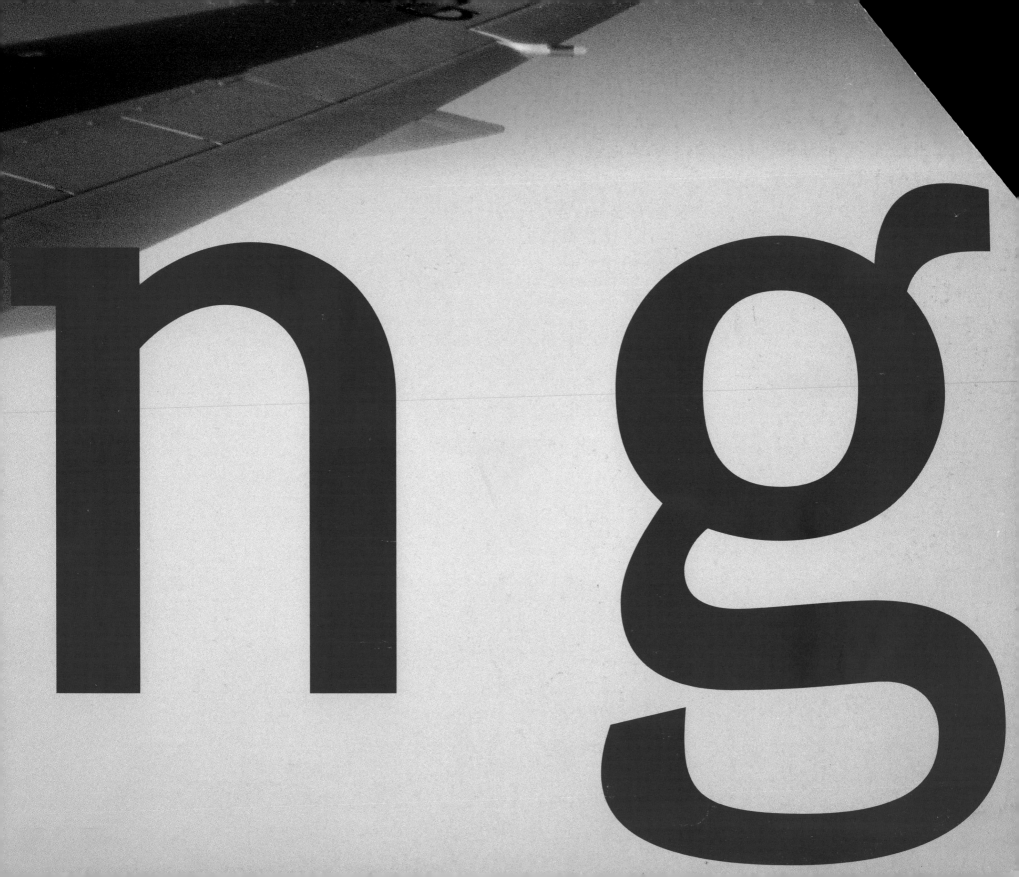

SELDOM do a word and an image achieve a oneness like the wings on the **preceding page.** Why do they seem so right for one another? The wing and the "w" share diagonals; the dot of the "i" aligns with the axis of the wing; the wing and the "n" both have serifs; the dot and the "g" provide rounded relief from straight edges. Scale and color do their part. (DOES ANALYSIS KILL ART?)

Violation of the airspace with t e x t would be a crime against the integrity of the v o i d.

104.
105]

DOES PHOTOGRAPHY LIE? IS THIS
REALLY CHICAGO? THIS IS NOT
THE CHICAGO I VISITED. THIS
IS THE CHICAGO DAVID VISITED.
IF I RETURN TO CHICAGO I
WILL SEE IT IN A DIFFERENT
WAY. I WILL SEE THE SKY.

ON first seeing this photograph of a young woman in Paris, I thought she was grieving,

upset, or depressed. After learning she was giggling, I realized once again how photographs
hide their meaning; they are often ambiguous and open

to many different interpretations. Sentences are

usually more specific and unequivocal, revealing an

exact MEANING.

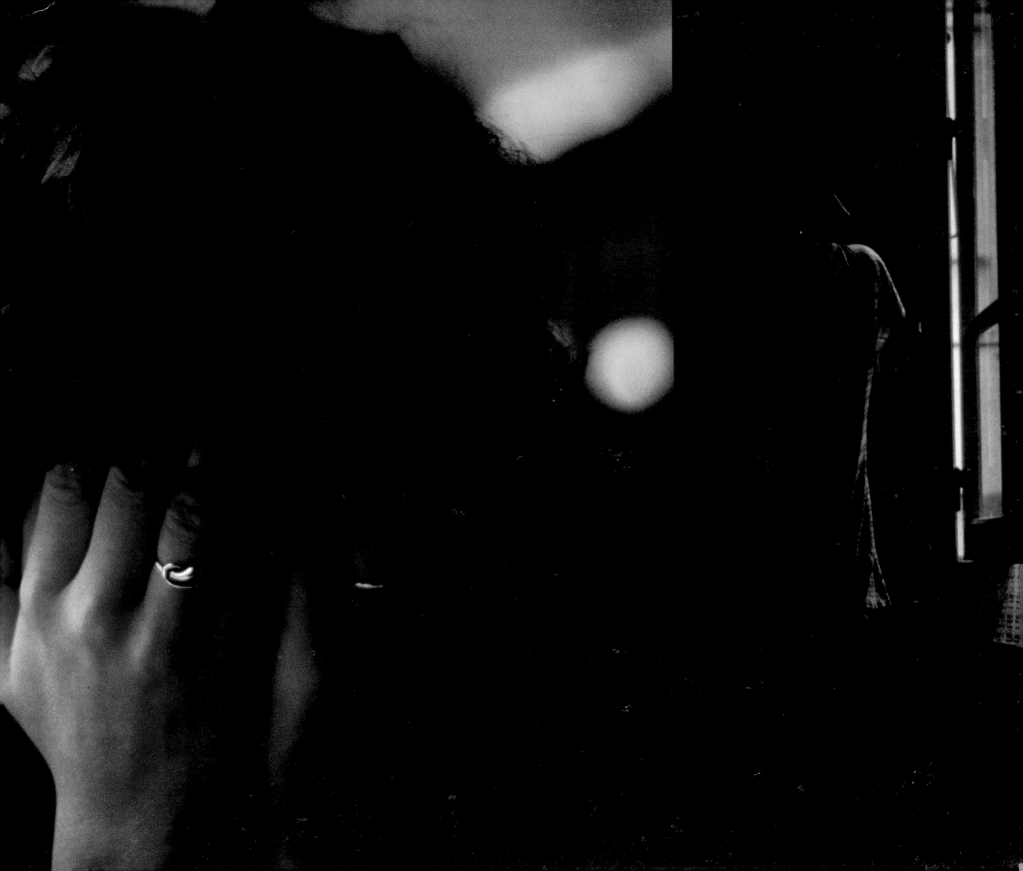

3,8

4,3

Liberated from their semantics by the photograph's edges, glyphs

become the material for art.

In New Zealand, the authorities made the owner of this massage parlor allegedly involved in prostitution remove two letters. Passers-by now wonder if the sign said "massage" or "message". Local residents know what business is located there, while visitors associate the missing letters with an empty building.

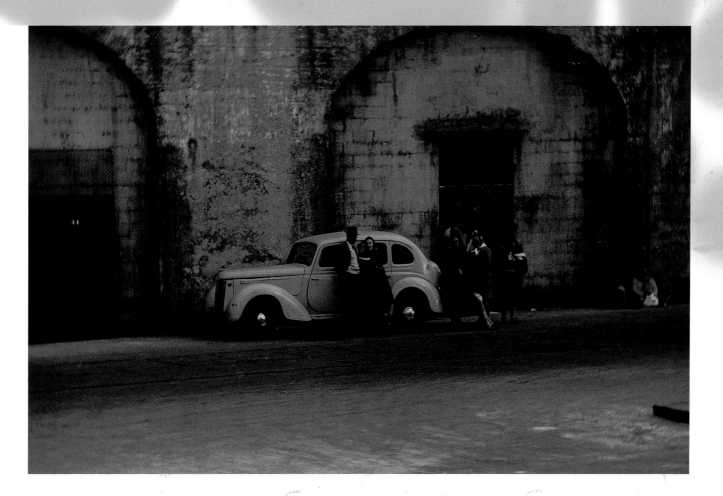

I am often SURPRISED by new photographs that look very old, and old photographs that look very new. A vintage motor car yanks this photograph a half-century backwards in time.

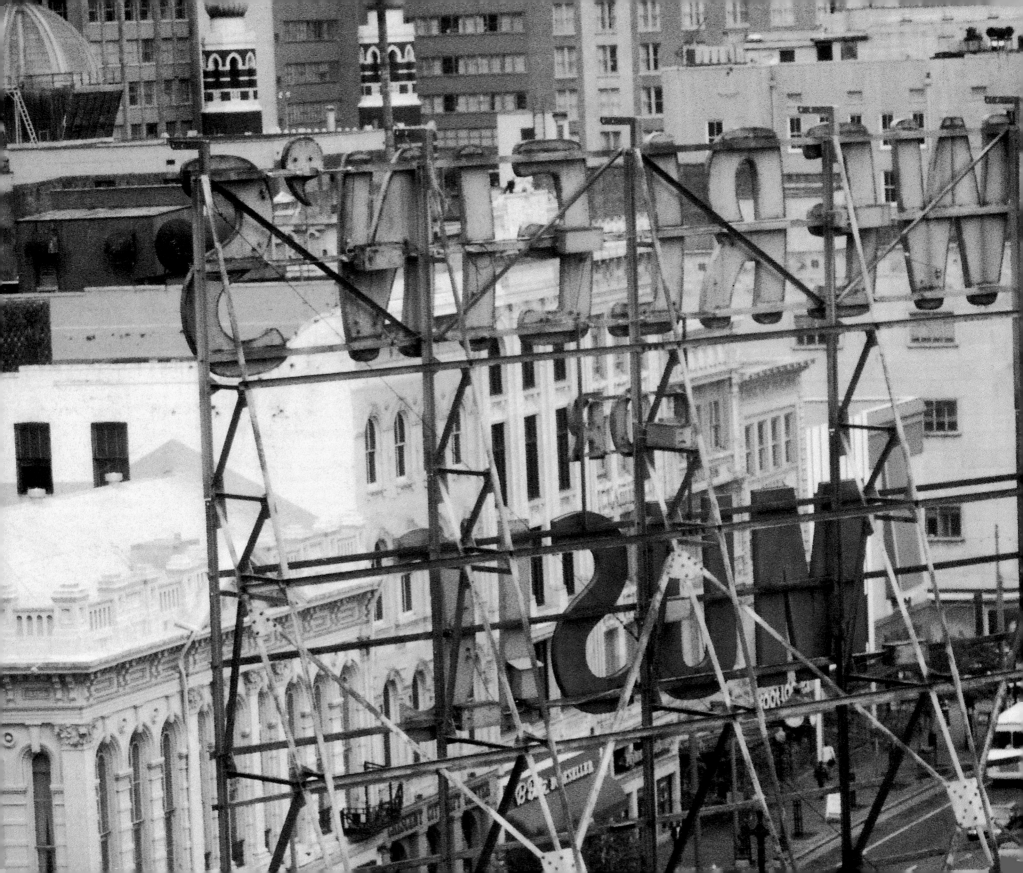

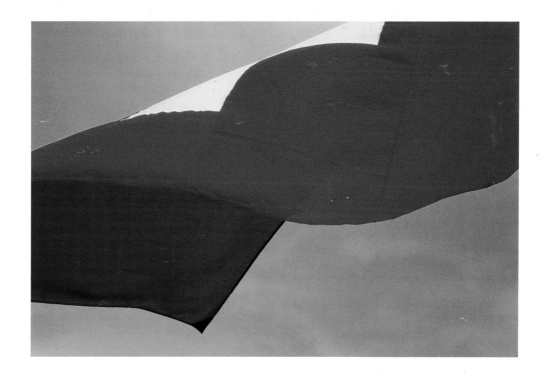

110)

THE PUBLIC FACADE OF ENVIRONMENTAL SIGNS FLOATING OVER CITIES ARE RARELY AS INTERESTING AS THEIR DIMENSIONAL SUPPORTS. THE FRONT OF A SIGN OR BUILDING IS COSMETIC, A PAINTED FACE TO PRESENT A CAREFULLY CONTRIVED IMAGE. THE BACK CONTAINS FORMS DETERMINED BY FUNCTIONAL DEMANDS.

111)

TWISTING IN THE WIND, THE WHITE CROSS AND RED FIELD OF THE SWISS FLAG ARE TRANSFORMED INTO AN UNRECOGNIZABLE GROUP OF SHAPES.

VENEZIA

THE WORLD IS A VERY DIFFERENT PLACE IN THE EARLY MORNING. THIS PHOTOGRAPH WAS TAKEN WHEN DAVID HEADED TO THE VENICE AIRPORT IN A WATER TAXI. IT IS AN ASPECT OF VENICE MANY VISITORS SEE, BUT IT IS NOT INCLUDED IN THE GUIDEBOOKS.

A Hamburg bus, used to ferry passengers to the airport.

The aged aesthetic of an ancient walkway wall.

A simple sign for a German motorscooter shop.

Two vehicles facing inward generate the cohesion and internal dynamic of this layout. Rules about page design, compiled for the benefit of yearbook staff, are often violated with effective results. The adage about having people and things facing into the spread, rather than out of it, can be broken quite successfully. When I switched the pages, the outward movement of the vehicles created an effective composition as well.

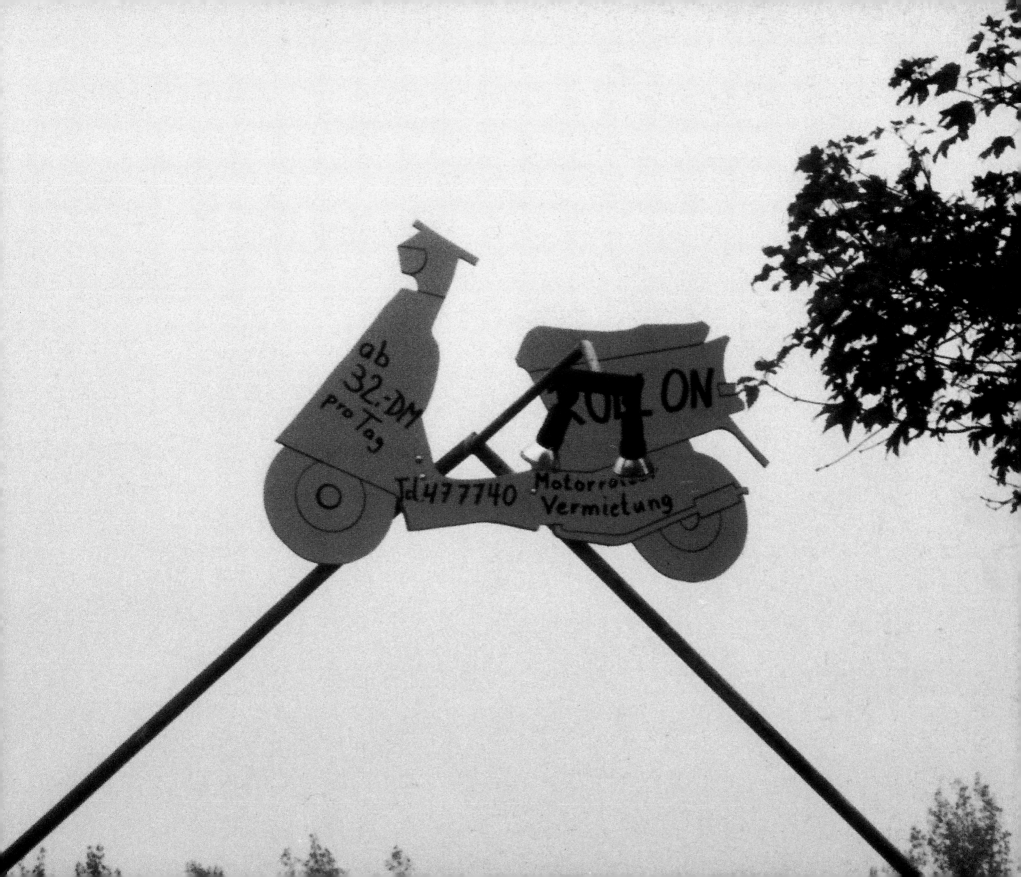

Traffic signs are common currency within their domain, but to the
uninitiated they become form stripped bare of its content, even ■

)Lurs,france
hamburg(

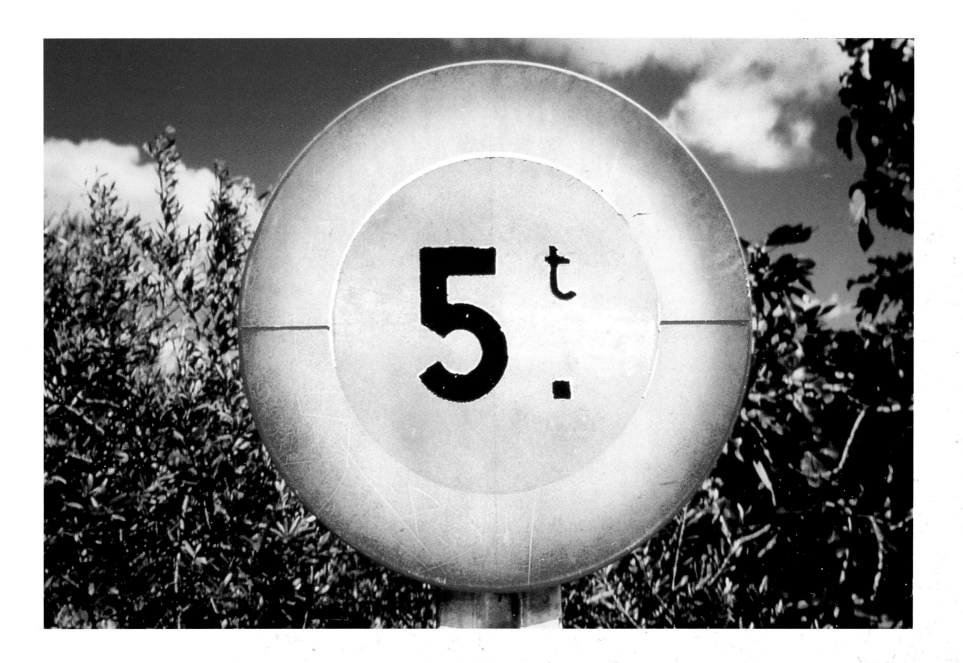

A DRIVE-BY SHOT from a rapidly moving vehicle is a chance attempt to capture the glimpse and make it permanent. There is little time and even less control. It is an act of modest urgency, for on our travels we seldom pass that way again. DRIVE-BY shot. David's emblematic title implies yet another parallel between hand-held machines: cameras (to capture and preserve)

and guns (to kill and maim). With the camera, a hit or a miss carries benign consequences.

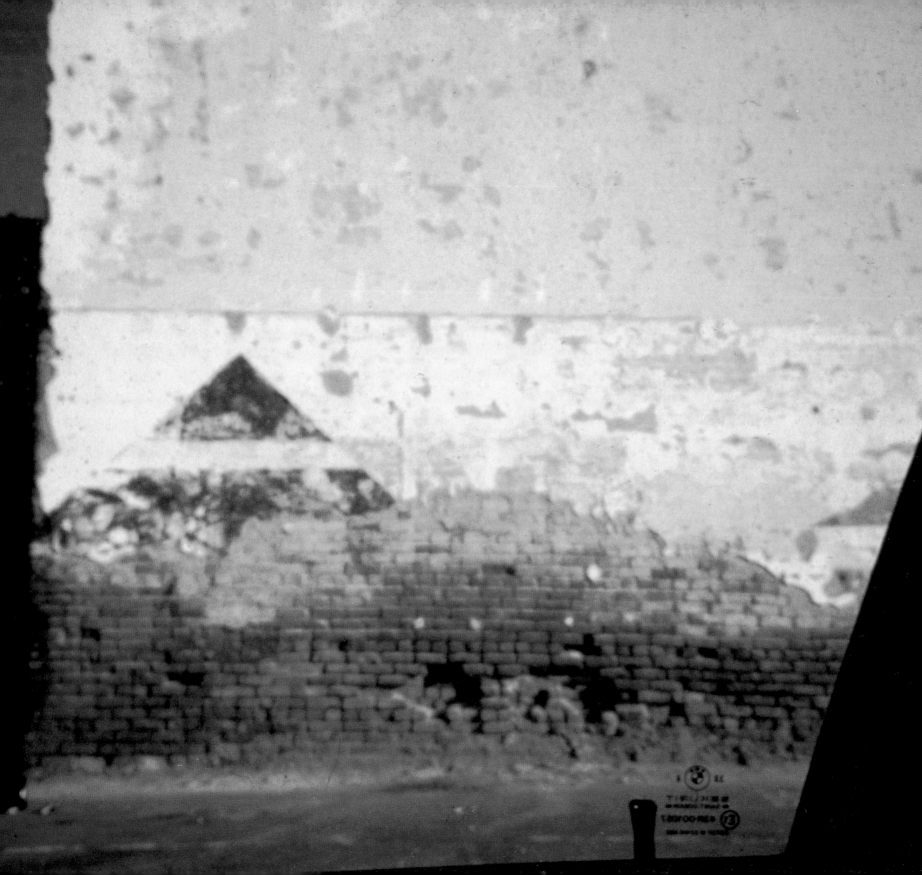

120.*121.LEFT*. TAXI FROM HEATHROW AIRPORT INTO LONDON.

RIGHT: WINE

COUNTRY CRUISING, FRANCE, 1998.

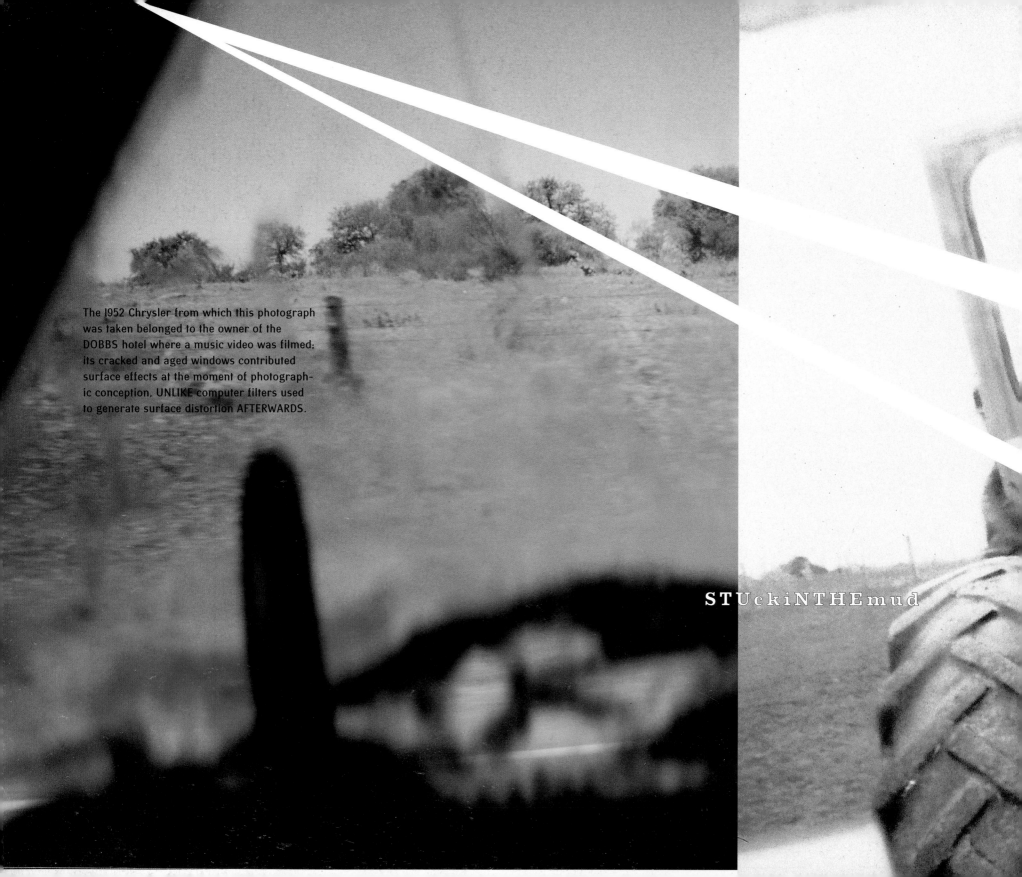

The 1952 Chrysler from which this photograph was taken belonged to the owner of the DOBBS hotel where a music video was filmed; its cracked and aged windows contributed surface effects at the moment of photographic conception, UNLIKE computer filters used to generate surface distortion AFTERWARDS.

STUckiNTHEmud

RESCUE.NewZealand.

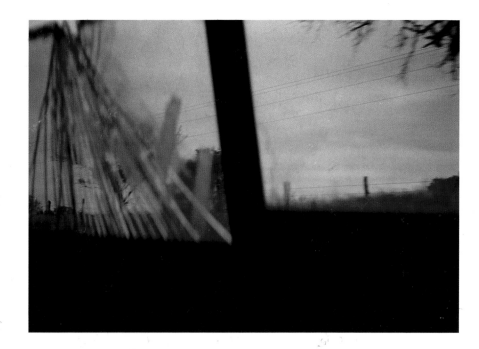

More Texas drive-by shootings from the 1952 Chrysler.

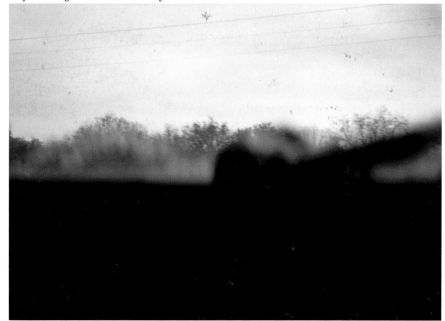

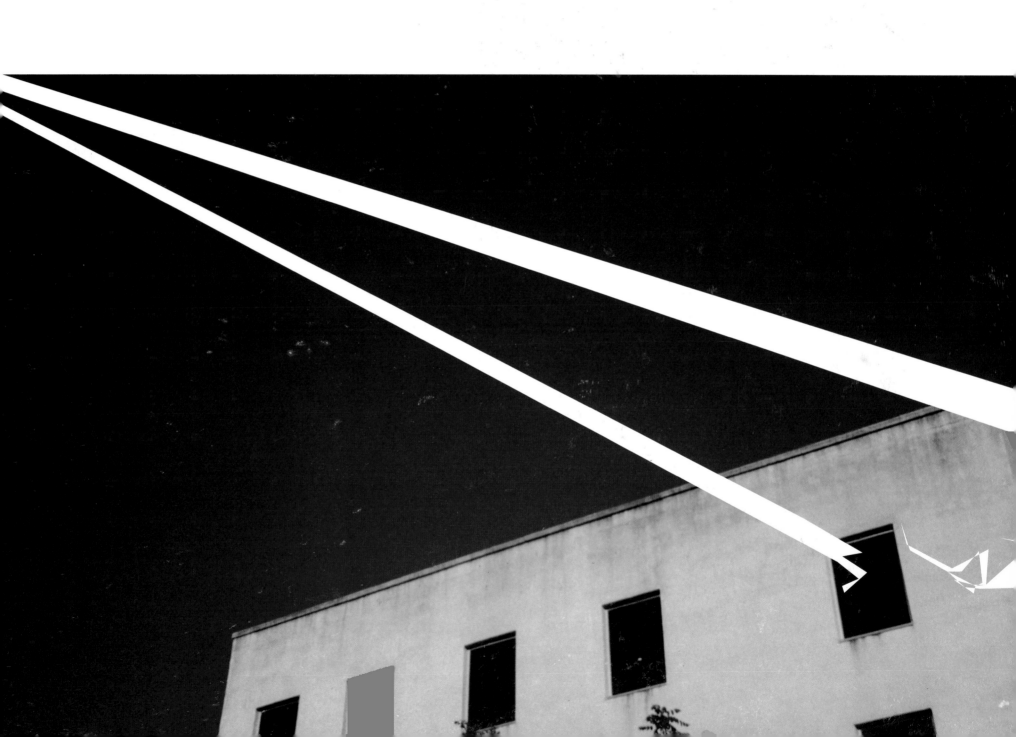

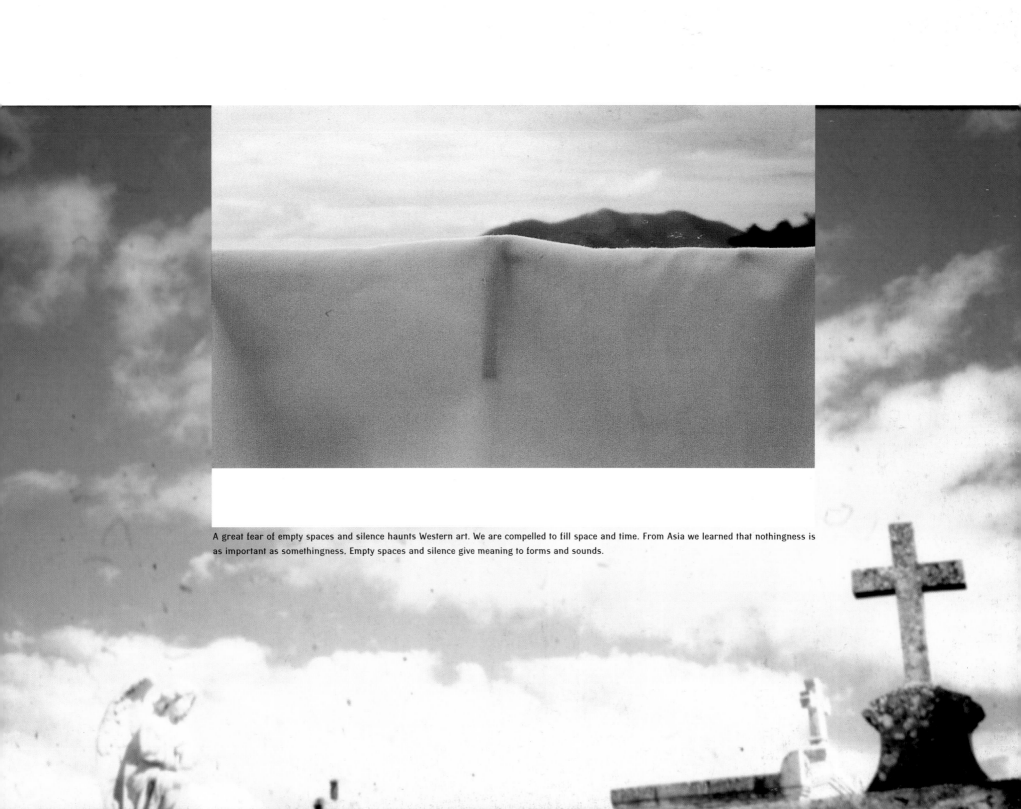

A great fear of empty spaces and silence haunts Western art. We are compelled to fill space and time. From Asia we learned that nothingness is as important as somethingness. Empty spaces and silence give meaning to forms and sounds.

T o /

Environments are often invisible to the those who live in them. Visitors see them with
 fresh eyes, experiencing wonder at the amazing edifices that seem perfectly
ordi

nary to long-time RESIDENTS.

1 30.**131**

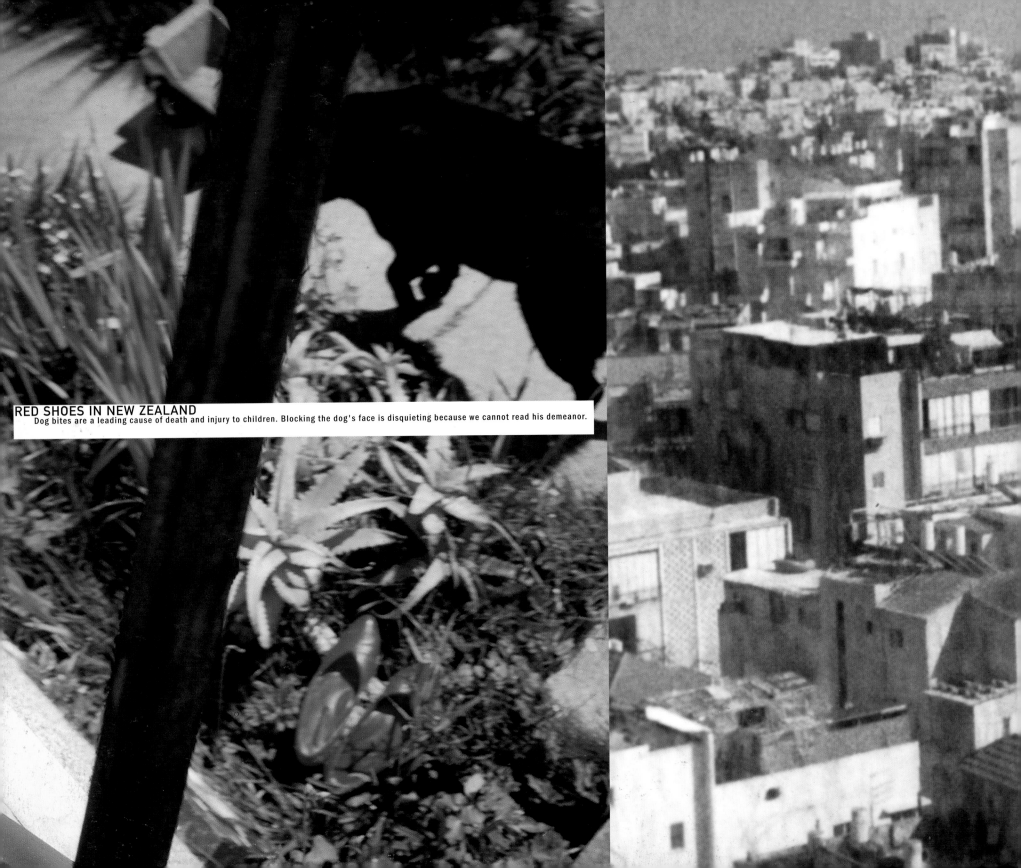

RED SHOES IN NEW ZEALAND
Dog bites are a leading cause of death and injury to children. Blocking the dog's face is disquieting because we cannot read his demeanor.

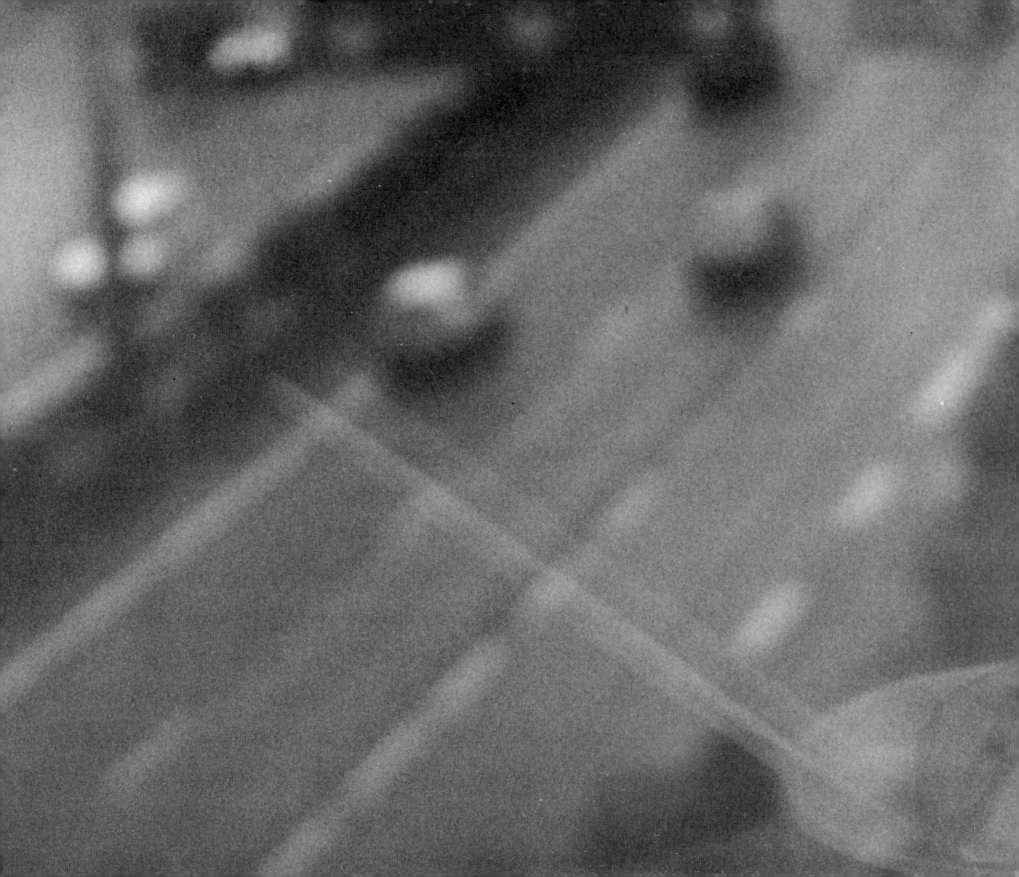

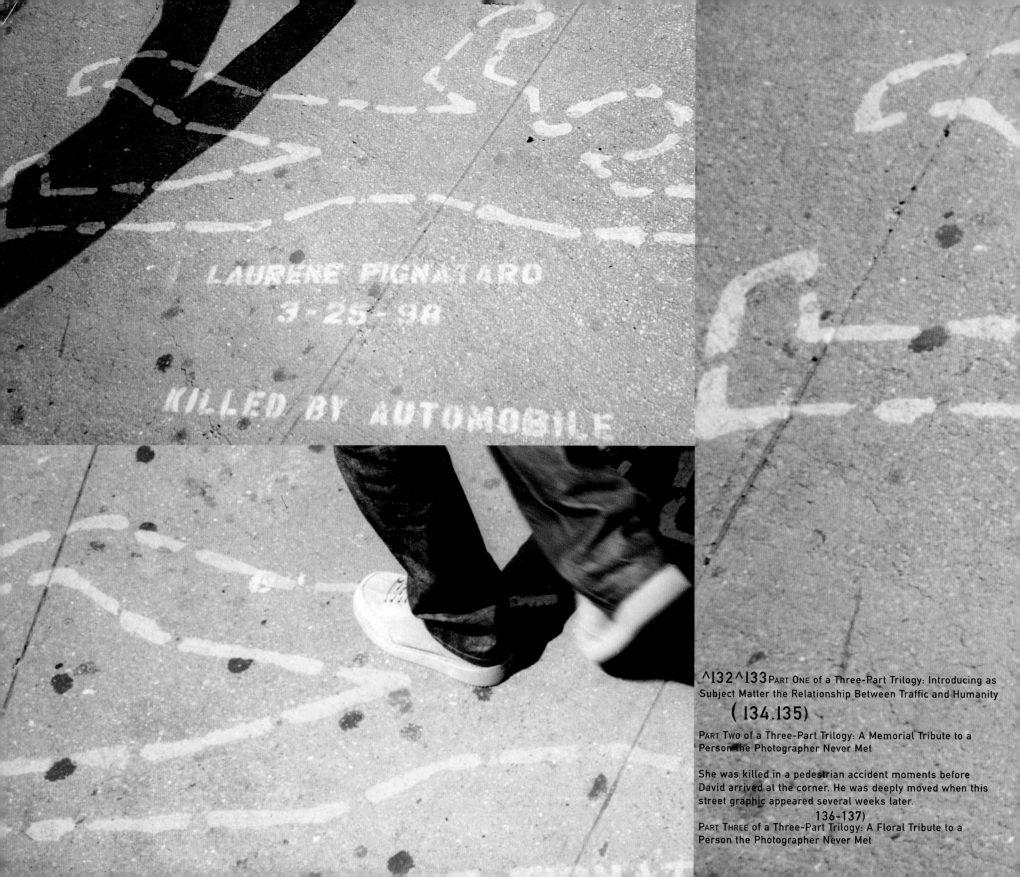

LAURENE PIGNATARO
3-25-98

KILLED BY AUTOMOBILE

^132^133 PART ONE of a Three-Part Trilogy: Introducing as Subject Matter the Relationship Between Traffic and Humanity

(134.135)

PART TWO of a Three-Part Trilogy: A Memorial Tribute to a Person the Photographer Never Met

She was killed in a pedestrian accident moments before David arrived at the corner. He was deeply moved when this street graphic appeared several weeks later.

136-137)

PART THREE of a Three-Part Trilogy: A Floral Tribute to a Person the Photographer Never Met

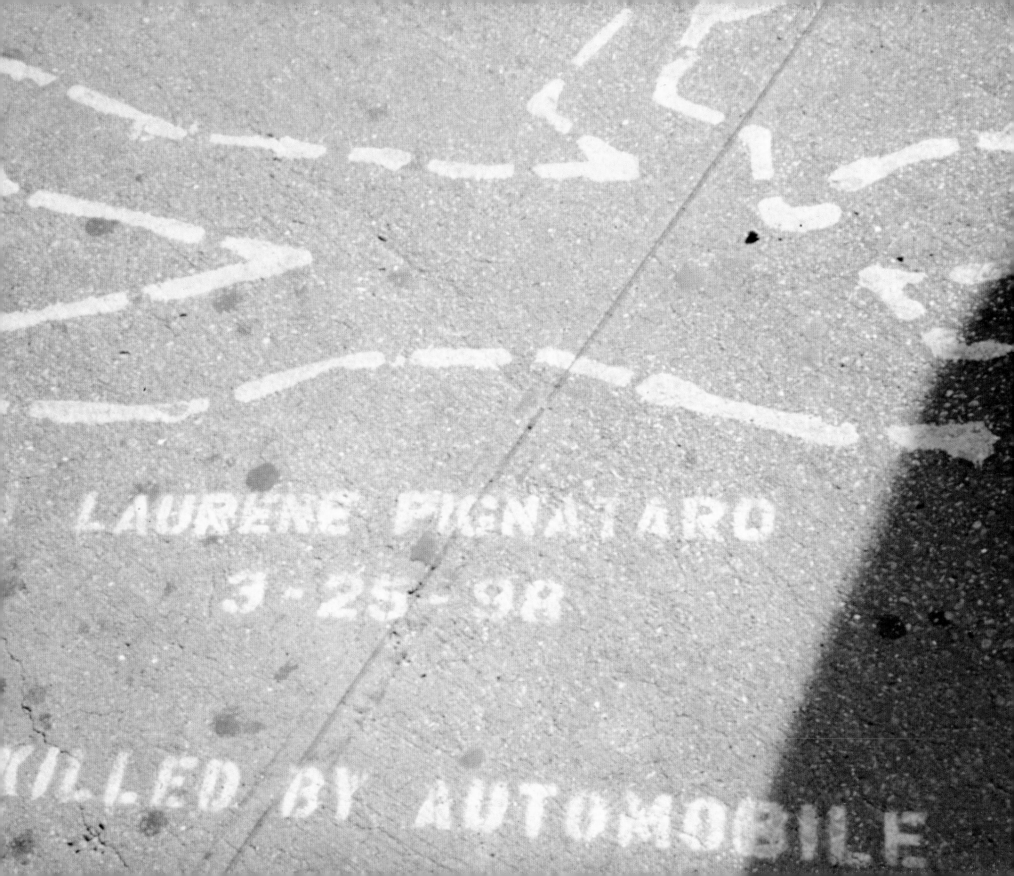

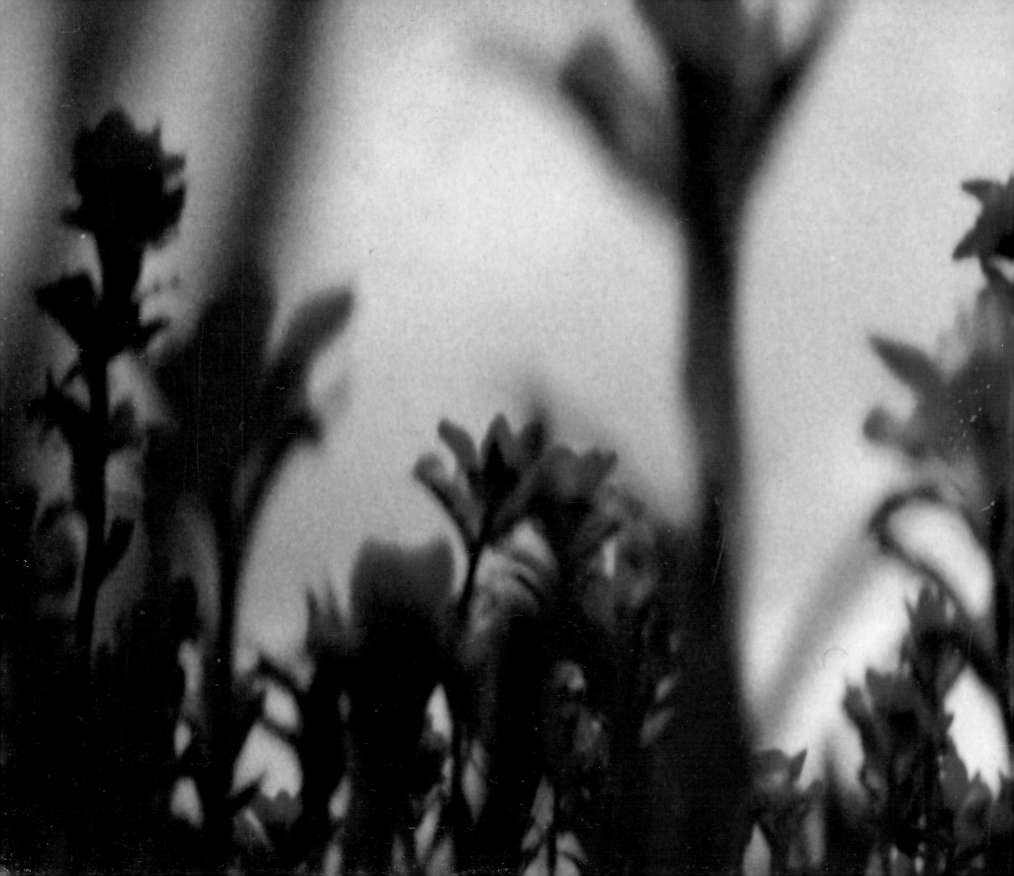

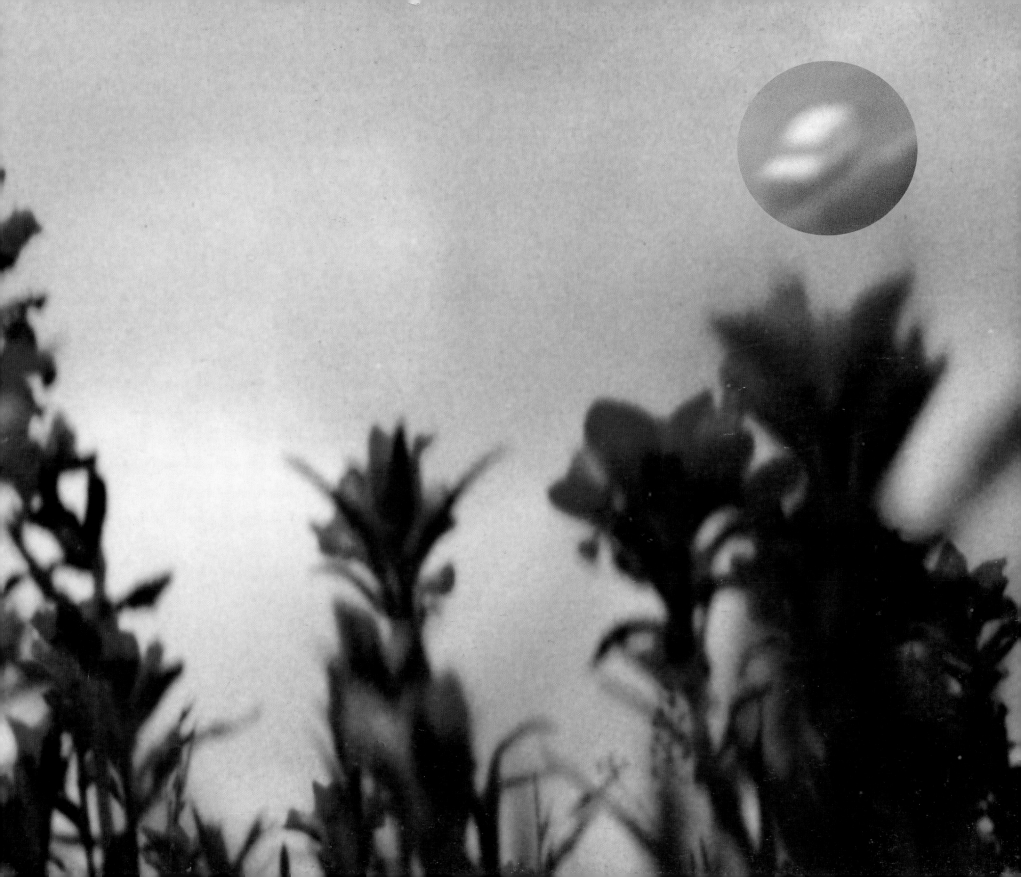

Beach Culture magazine, January 1990. Design: David Carson. Illustration: Hays Henderson

Emigre magazine, July 1990. Design: Rudy VanderLans. Photo: Rudy VanderLans

DC: "Fringe, or 'underground' magazines have always included the work of 'amateur' illustrators and photographers. *Beach Culture* and *Emigre* magazines (above) continued this tradition in the early 1990s. Rudy VanderLans was, and continues to be, underrated as a photographer."

When John Cage spoke years ago at Virginia Commonwealth University School of the Arts where I teach, he said, "If you're bored with a thing, do it again. If you are still bored with it, do it again. . . and again, until you are not bored with it."

Cage seems to be suggesting that boredom exists in our minds, not in the sights and sounds of our environment. If we discard our prejudices and preconceptions, mundane activities can become dance; a dripping faucet can become music; debris in the street can become a found painting.

Does Cage's observation hold meaning for photography? If a photograph bores you, should you look at it again? And again, until it stops boring you? Some photographs continue to bore us, anyway. Either they lack the magic of art, or the power of an engaging subject, or we are not perceptive enough to understand them.

This photograph of a chair bored me on first sight, but upon viewing it again I realized it was not about the chair, but about the absence of people. It began to fascinate me.

(139

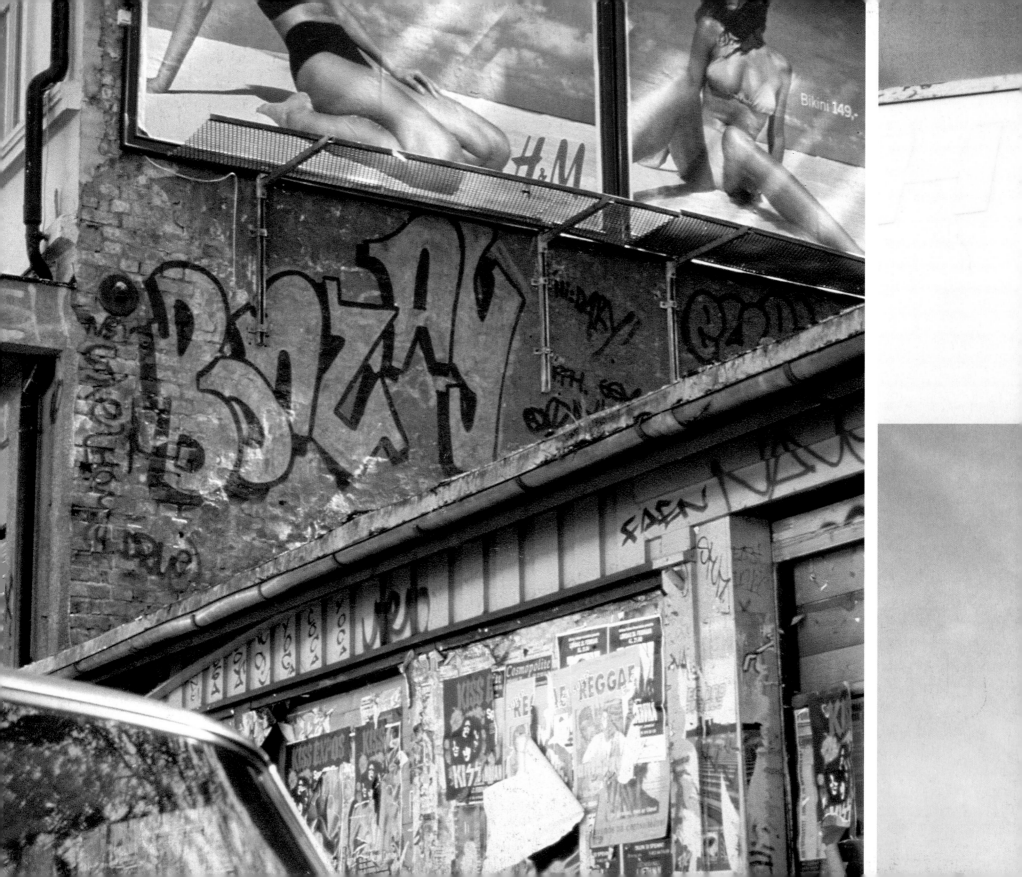

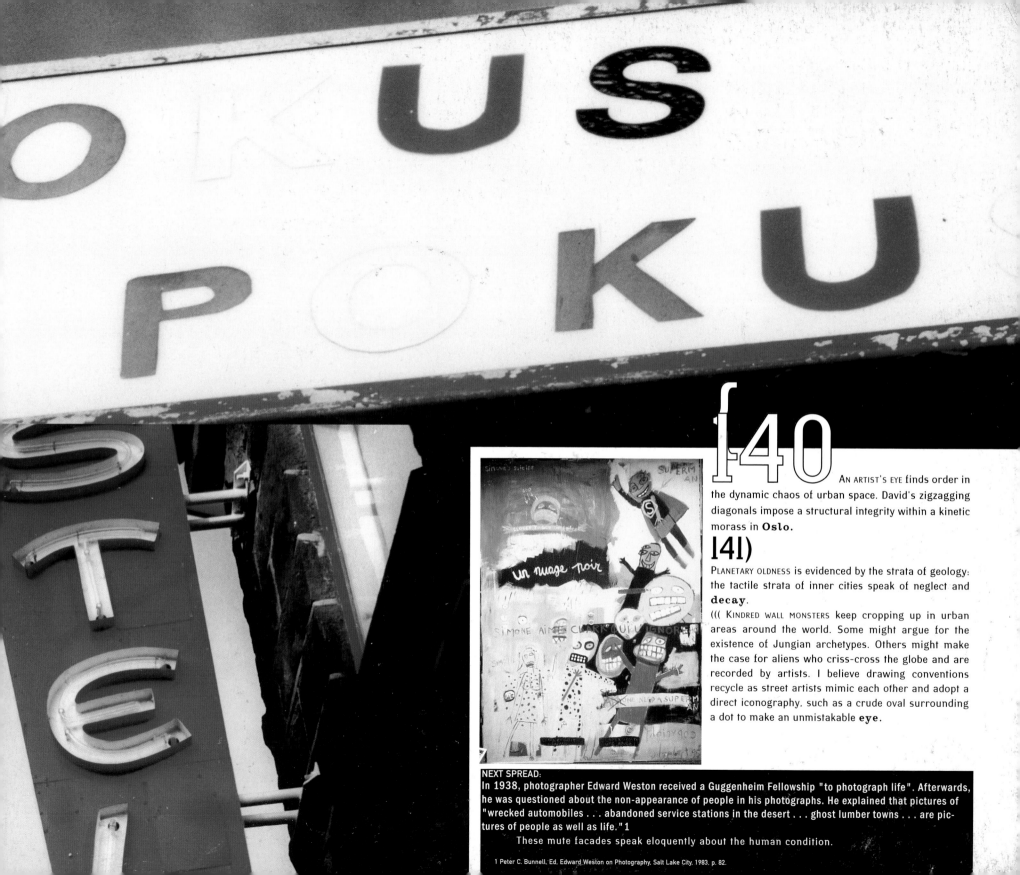

f40

AN ARTIST'S EYE finds order in the dynamic chaos of urban space. David's zigzagging diagonals impose a structural integrity within a kinetic morass in **Oslo**.

(41)

PLANETARY OLDNESS is evidenced by the strata of geology: the tactile strata of inner cities speak of neglect and **decay**.

(((KINDRED WALL MONSTERS keep cropping up in urban areas around the world. Some might argue for the existence of Jungian archetypes. Others might make the case for aliens who criss-cross the globe and are recorded by artists. I believe drawing conventions recycle as street artists mimic each other and adopt a direct iconography, such as a crude oval surrounding a dot to make an unmistakable **eye**.

NEXT SPREAD:
In 1938, photographer Edward Weston received a Guggenheim Fellowship "to photograph life". Afterwards, he was questioned about the non-appearance of people in his photographs. He explained that pictures of "wrecked automobiles . . . abandoned service stations in the desert . . . ghost lumber towns . . . are pictures of people as well as life."1
 These mute facades speak eloquently about the human condition.

1 Peter C. Bunnell, Ed, Edward Weston on Photography, Salt Lake City, 1983, p. 82.

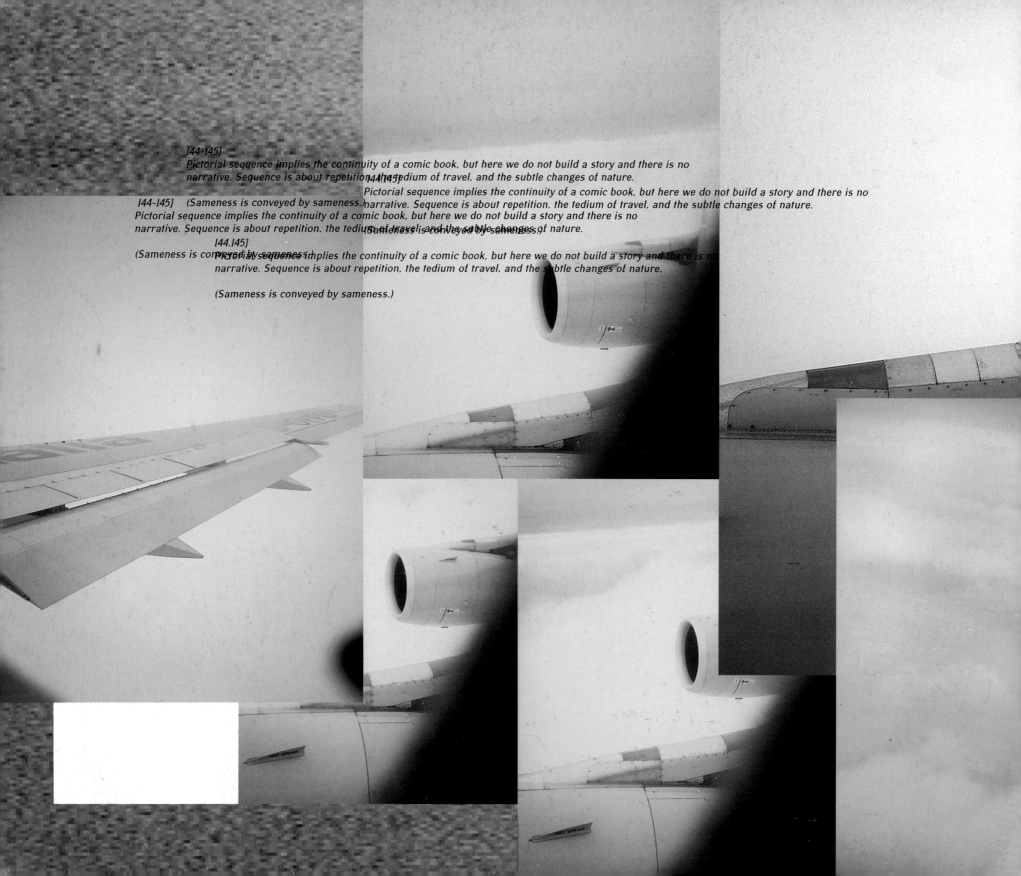

[44-I45]
Pictorial sequence implies the continuity of a comic book, but here we do not build a story and there is no narrative. Sequence is about repetition, the tedium of travel, and the subtle changes of nature.

Pictorial sequence implies the continuity of a comic book, but here we do not build a story and there is no narrative. Sequence is about repetition, the tedium of travel, and the subtle changes of nature.

[44-I45] (Sameness is conveyed by sameness.)
Pictorial sequence implies the continuity of a comic book, but here we do not build a story and there is no narrative. Sequence is about repetition, the tedium of travel, and the subtle changes of nature.

(Sameness is conveyed by sameness.)

[44.I45]
(Sameness is conveyed by sameness.)Pictorial sequence implies the continuity of a comic book, but here we do not build a story and there is no narrative. Sequence is about repetition, the tedium of travel, and the subtle changes of nature.

(Sameness is conveyed by sameness.)

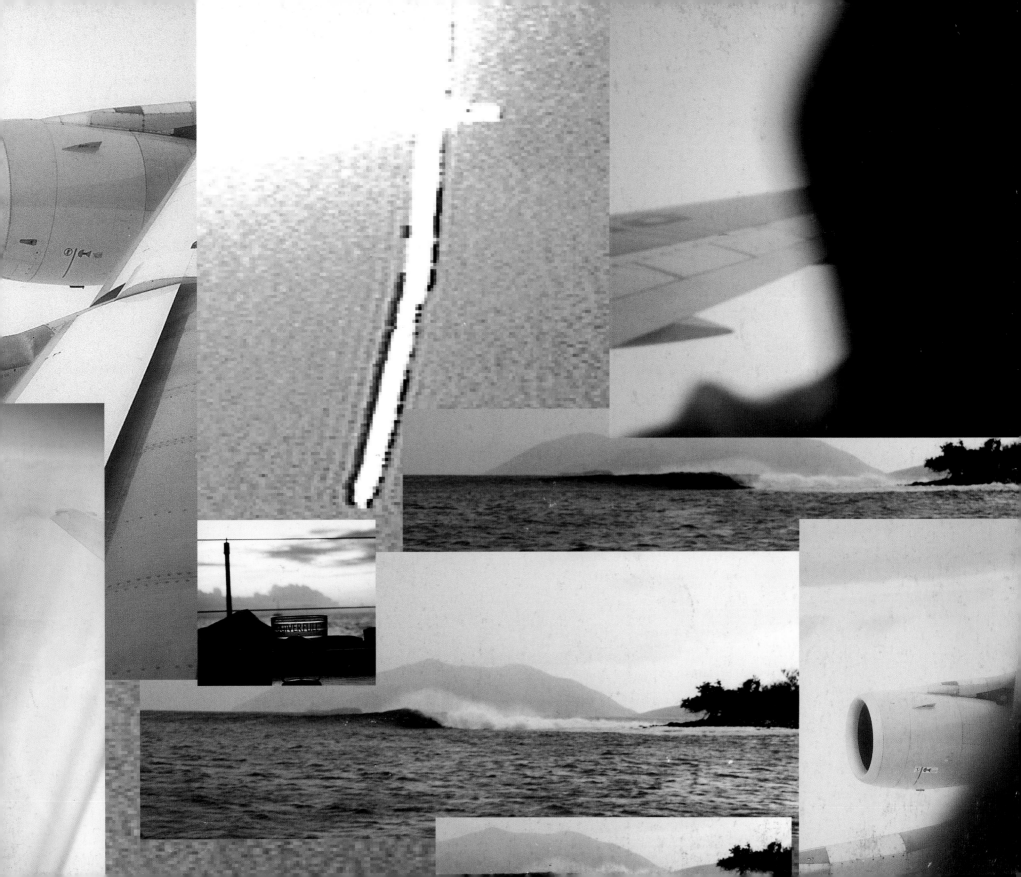

[46 147]

If one picture is worth a thousand words, how many words are four pictures worth? The question, along with the cliché, is probably irrelevant. But these four photographs do conspire to provide a more complete sense of bullet train travel than one photograph ever could.

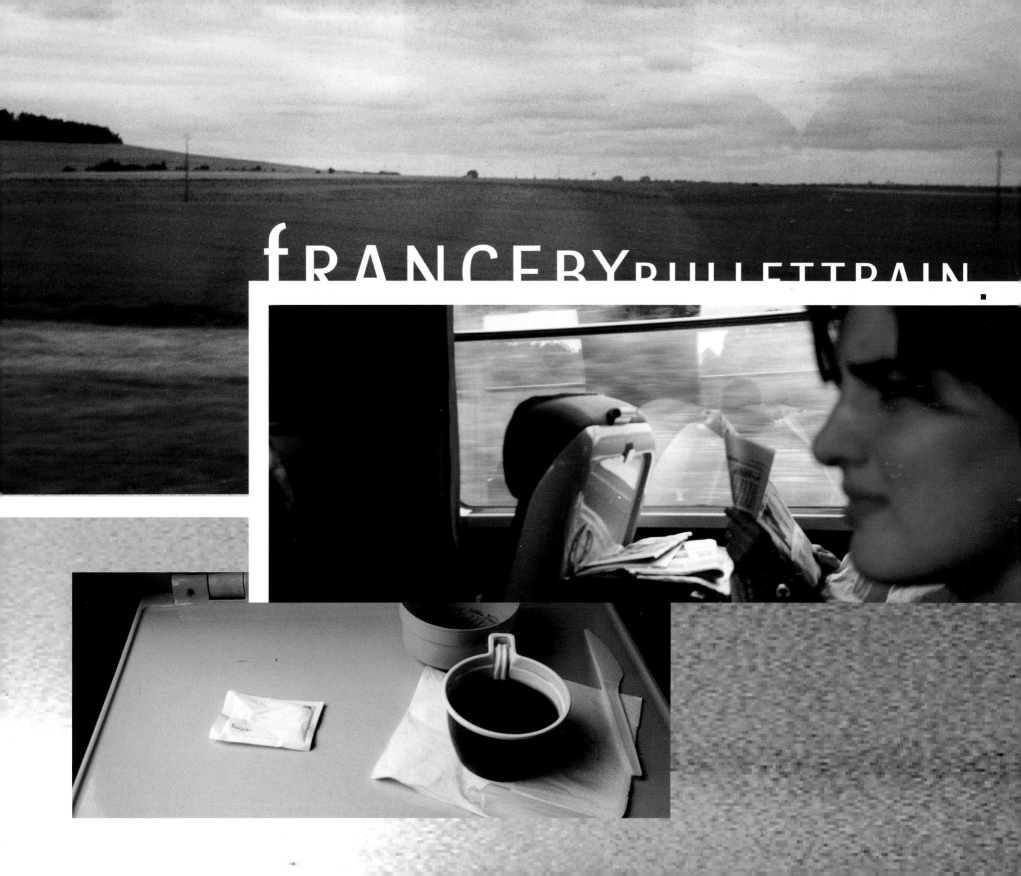

fRANCEBYBULLETTRAIN.

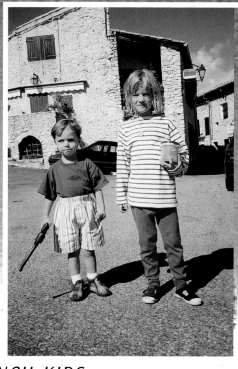

dc: "GOOD fRENCH KIDS,
 BAD french toys."

Lurs.france 1997

DC: "*In the British Virgin Islands, locals always*

stop and pick up walkers wanting a lift—it's really

not hitch-hiking—it's much friendlier than that.

Here's a group we picked up one day."

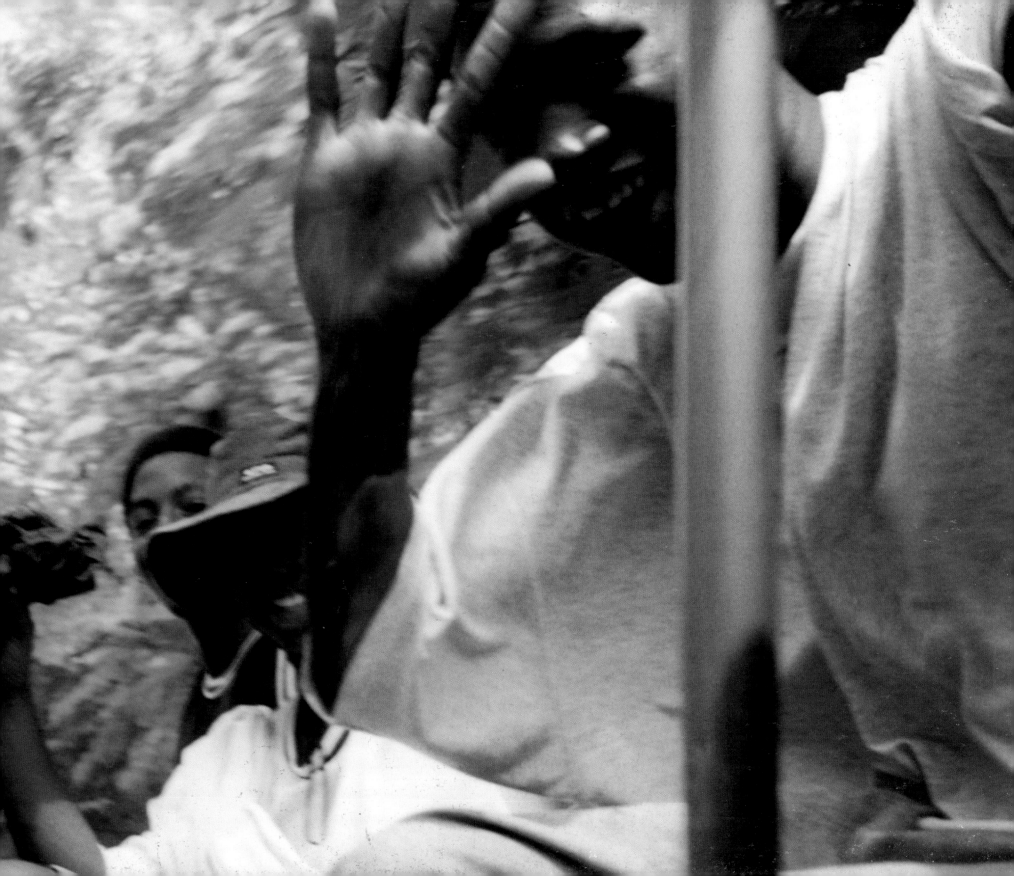

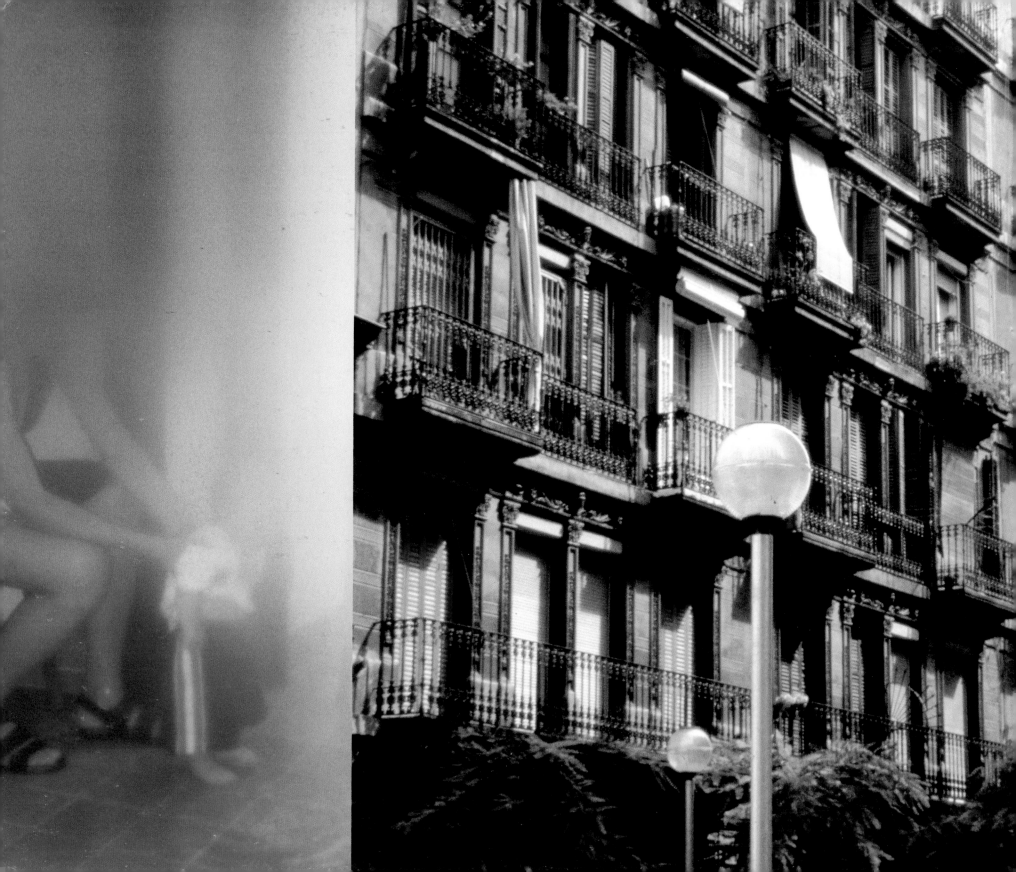

151

A young woman and her baby . . . a building in Europe . . . and two mannequins (perhaps I should call them real dummies) smoking on the roof as part of a cigarette advertising tableau . . . a blue sign in Italy . . . a friend photographed through a pale ale: this gathering of images presents no narrative, delivers NO AGENDA.

This visual feast was compiled intuitively. Verbal or conceptual messages are absent; photographic information is put together for the delight [or dismay] of the viewer. It is editorial design without the editorial part, for an intensely visual age.

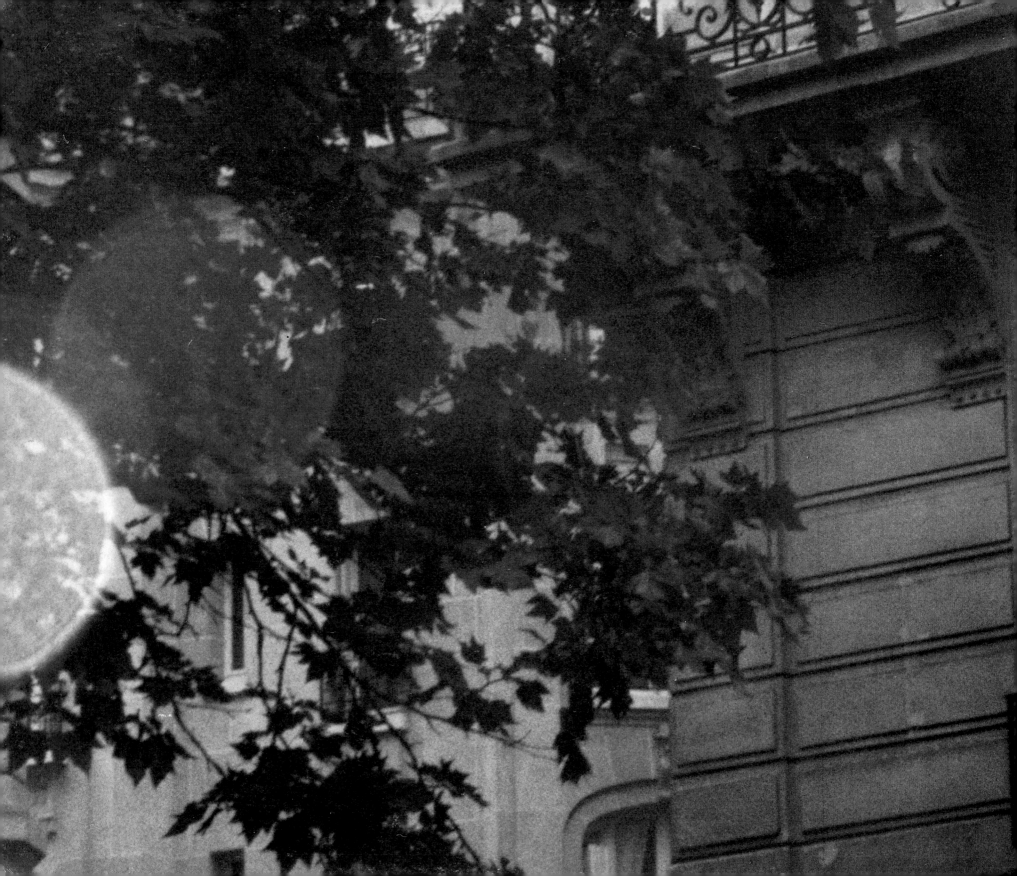

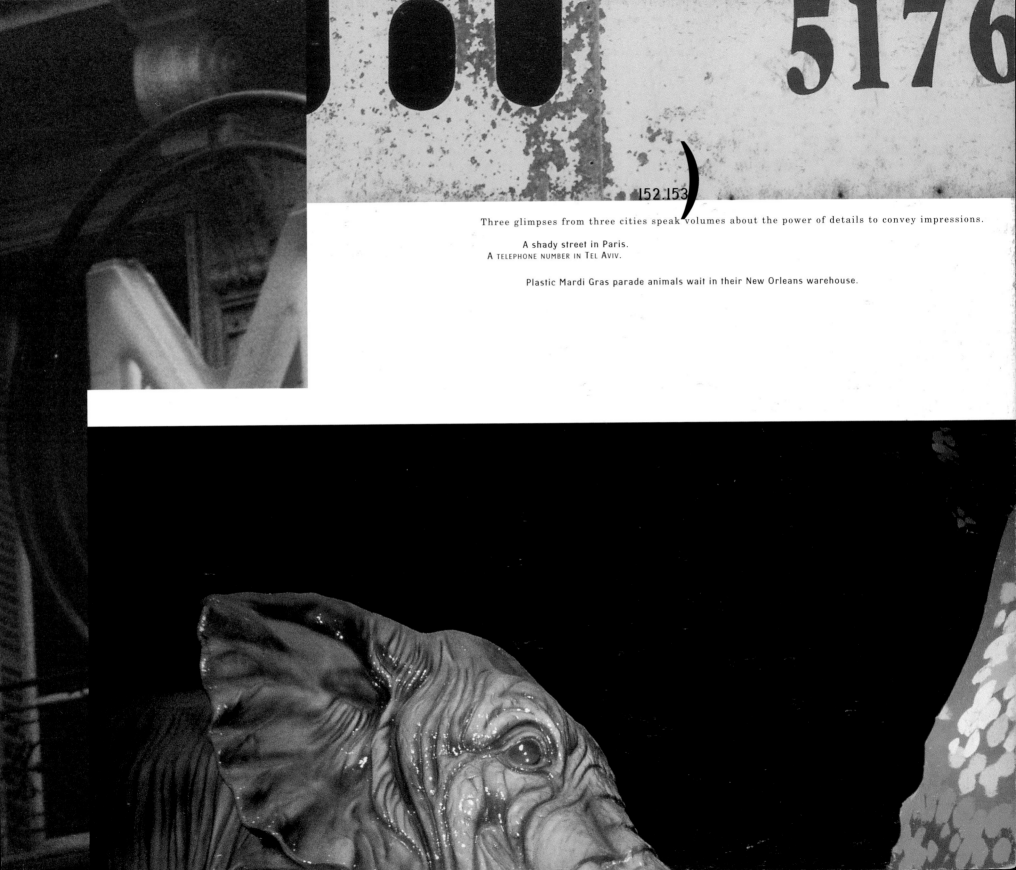

152.153

Three glimpses from three cities speak volumes about the power of details to convey impressions.

A shady street in Paris.
A TELEPHONE NUMBER IN TEL AVIV.

Plastic Mardi Gras parade animals wait in their New Orleans warehouse.

This photograph provides more evidence about how each person brings his or her experience
to an image. I've never seen this structure and didn't recognize it as an office building.
David sees this building every time he walks to his studio, and found my original caption about
CAMOUFLAGED ARCHITECTURE to be irrelevant.

manhattan

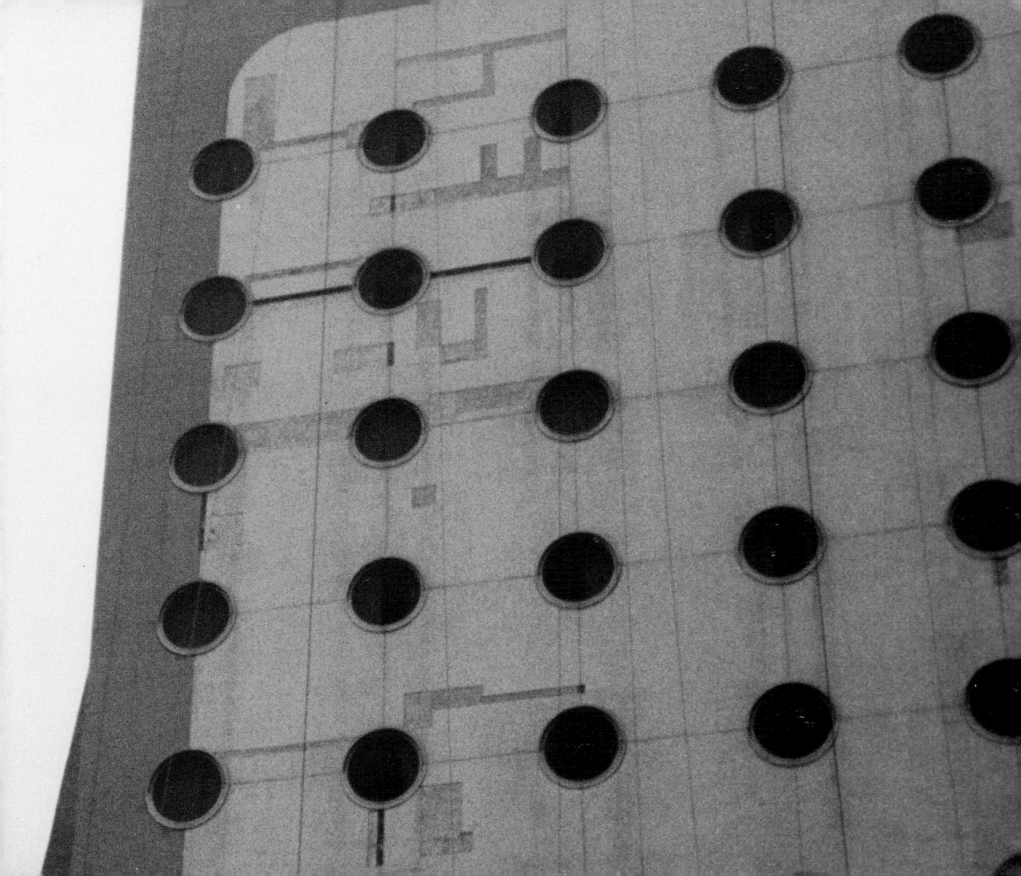

2nd-GRADE CLASSMATES

. school band

156.157]

A photograph made through a bottle forms a backdrop for youthful snap-shots of David's second-grade classmates. Perhaps there is no more important role for photography than as a preserver of personal and family history.

An exposure error by the box camera used for the top photograph actually increases its graphic power, becoming an omen of work to come.

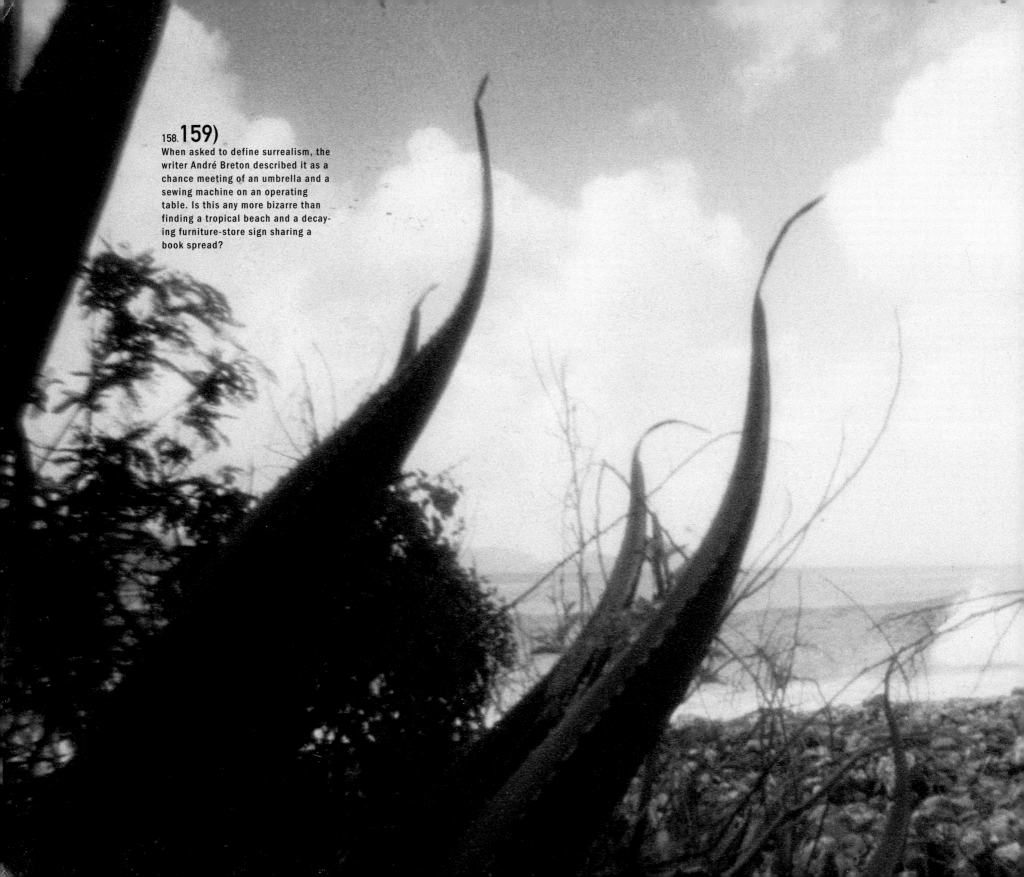

158.**159)**
When asked to define surrealism, the writer André Breton described it as a chance meeting of an umbrella and a sewing machine on an operating table. Is this any more bizarre than finding a tropical beach and a decaying furniture-store sign sharing a book spread?

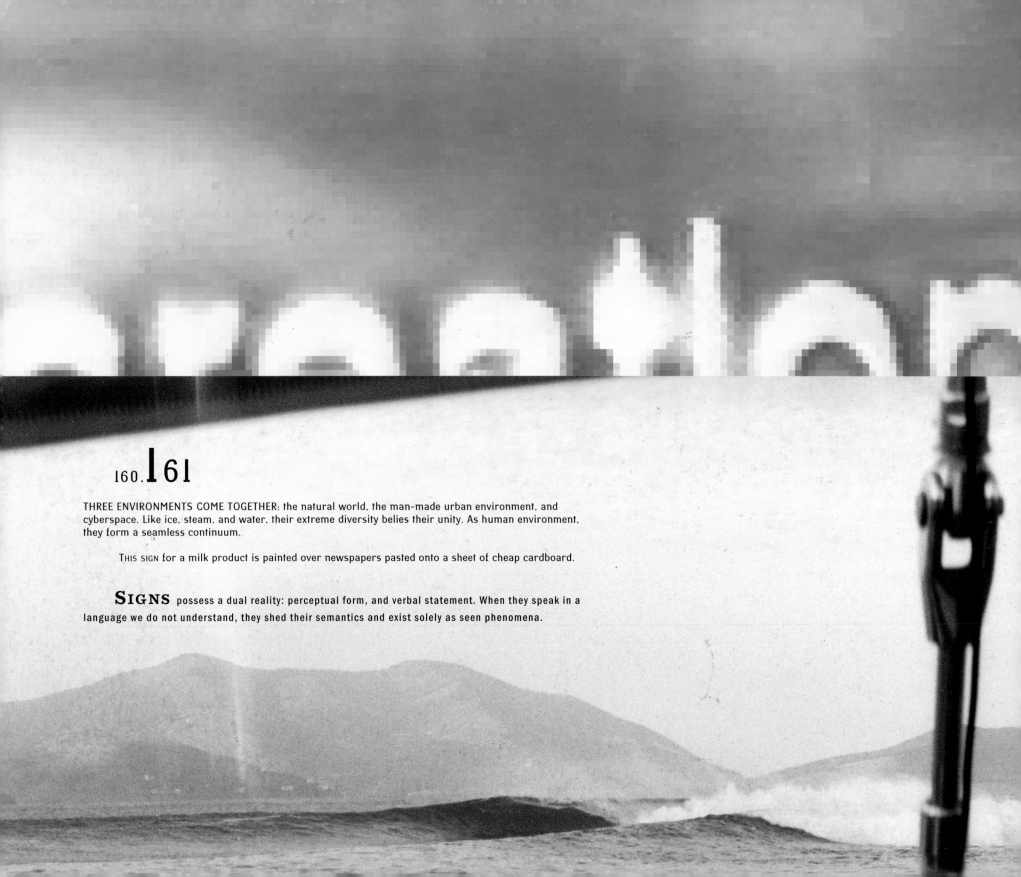

160.**161**

THREE ENVIRONMENTS COME TOGETHER: the natural world, the man-made urban environment, and cyberspace. Like ice, steam, and water, their extreme diversity belies their unity. As human environment, they form a seamless continuum.

THIS SIGN for a milk product is painted over newspapers pasted onto a sheet of cheap cardboard.

SIGNS possess a dual reality: perceptual form, and verbal statement. When they speak in a language we do not understand, they shed their semantics and exist solely as seen phenomena.

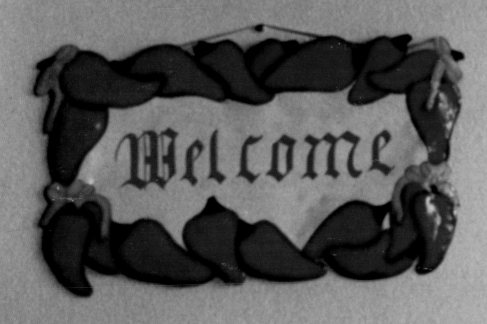

[62.163]
A sign with red peppers welcomes guests to a Christmas celebration at Tortola in the British Virgin Islands. But this photograph is not about holidays or peppers or family—it is about space.

*observation without boundaries.

>> DC: In a review in an art magazine, British writer Rick Poynor accused me of using "irrational point size changes" in my work. A friend and I thought it a hilarious pronouncement and made this celebratory t-shirt. (Typeface: Gladys, by Smokebomb Studios, NYC.) Maybe we were responding to the one-way communication in the design media. Maybe not.

During an interview I did for *Eye* magazine (commissioned by Poynor), the interviewer confided to me: "Rick's mad at you because he feels you got too famous from 'just doing a magazine'." Hmmm, I thought, that seems reasonable.

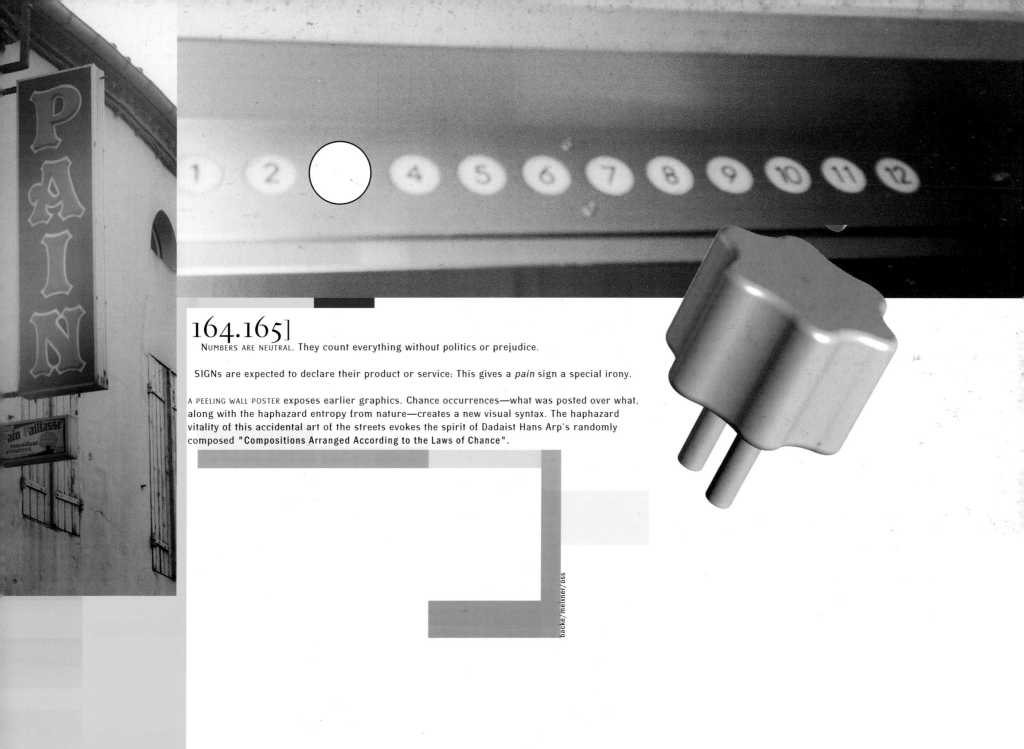

164.165]

NUMBERS ARE NEUTRAL. They count everything without politics or prejudice.

SIGNs are expected to declare their product or service; This gives a *pain* sign a special irony.

A PEELING WALL POSTER exposes earlier graphics. Chance occurrences—what was posted over what, along with the haphazard entropy from nature—creates a new visual syntax. The haphazard vitality of this accidental art of the streets evokes the spirit of Dadaist Hans Arp's randomly composed "Compositions Arranged According to the Laws of Chance".

backe/meixner/oss

166.16**?**]

The best signs are unequivocal. There can be no doubt about the nature of the business located here. One has

stumbled upon a boot shop. (IS THE SPEAR-LIKE SIGNPOST A SUBTLE REMINDER OF THE NECESSITY TO

PAY

THE BILL?)

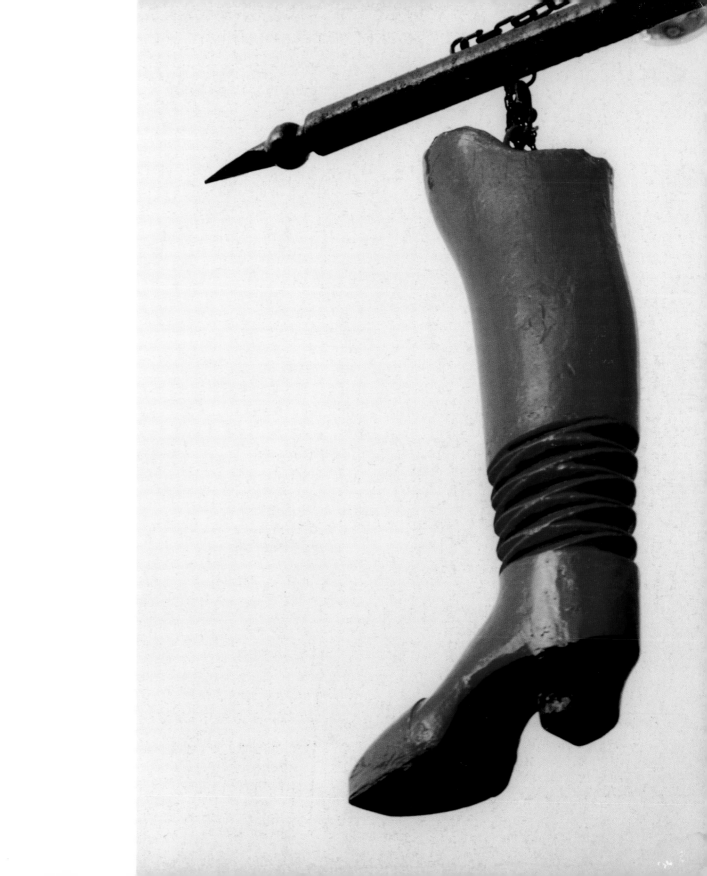

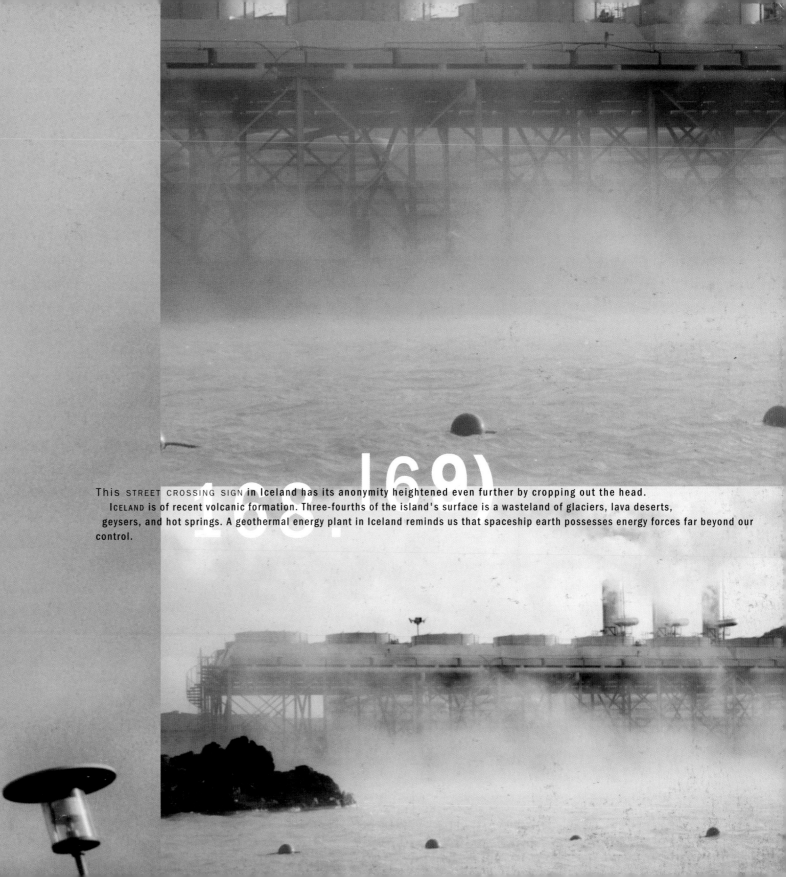

This STREET CROSSING SIGN in Iceland has its anonymity heightened even further by cropping out the head. ICELAND is of recent volcanic formation. Three-fourths of the island's surface is a wasteland of glaciers, lava deserts, geysers, and hot springs. A geothermal energy plant in Iceland reminds us that spaceship earth possesses energy forces far beyond our control.

168. 169)

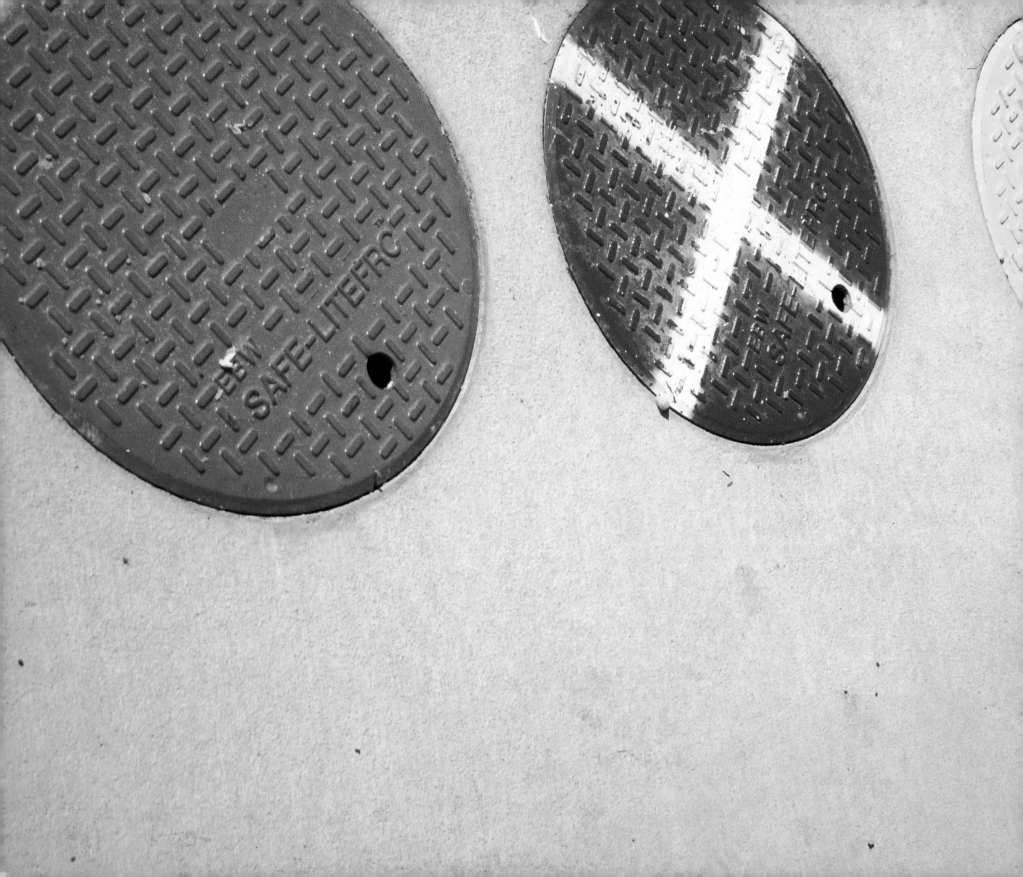

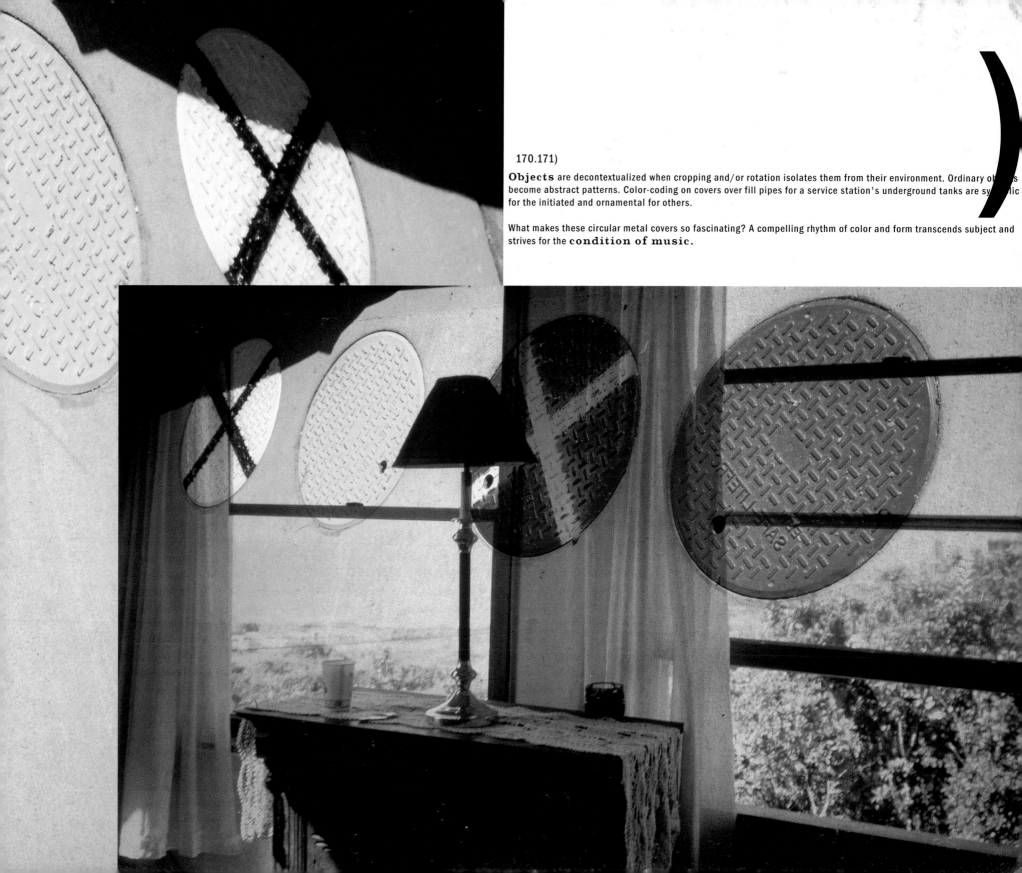

170.171)

Objects are decontextualized when cropping and/or rotation isolates them from their environment. Ordinary ob̶j̶e̶c̶t̶s̶ become abstract patterns. Color-coding on covers over fill pipes for a service station's underground tanks are sy̶m̶b̶o̶lic for the initiated and ornamental for others.

What makes these circular metal covers so fascinating? A compelling rhythm of color and form transcends subject and strives for the **condition of music.**

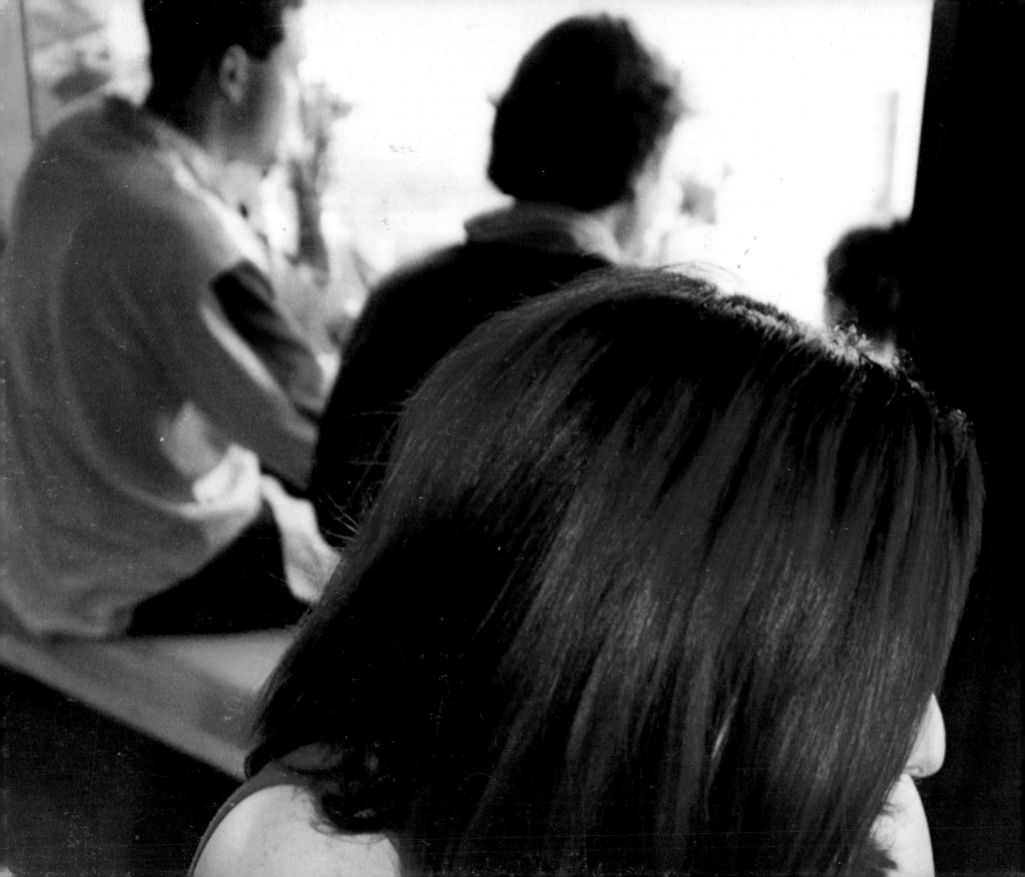

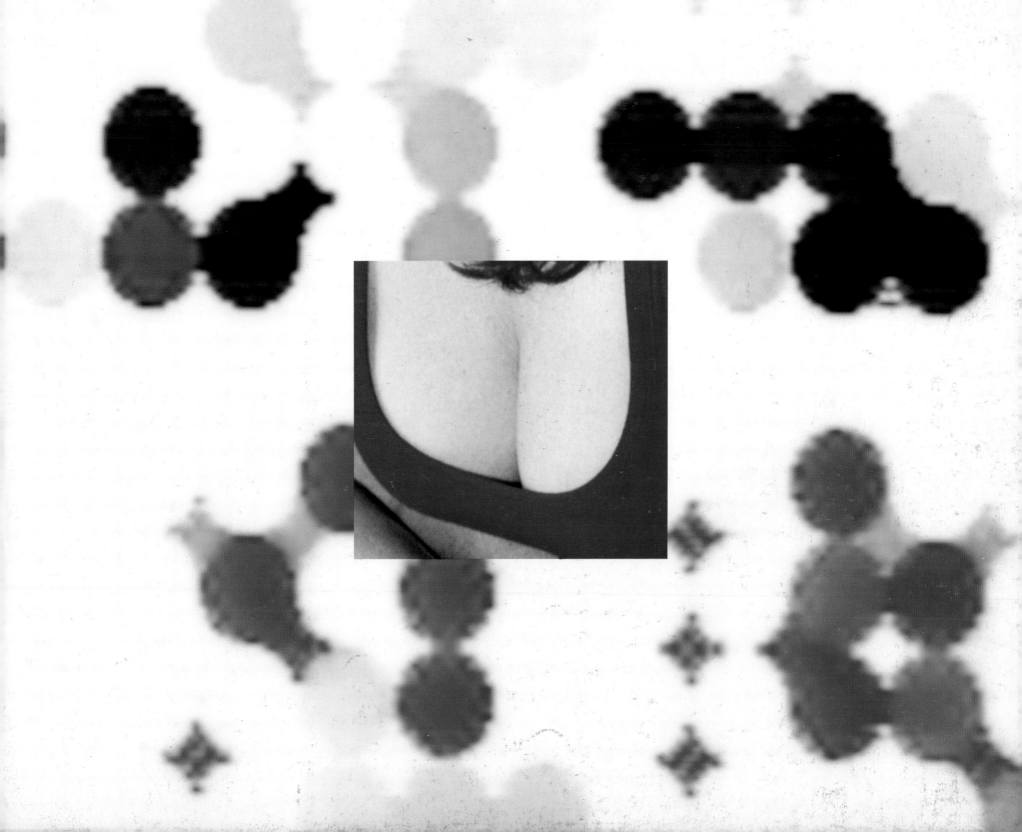

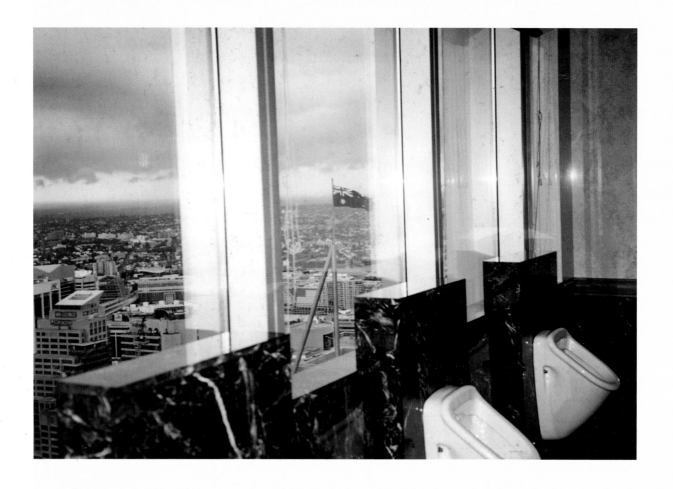

176]
"41" is the highest restaurant in Sydney. Reportedly, the third urinal from the right in its men's room has the best view of any urinal in Australia. (This is content-driven photography.)

177]
This old abandoned loft in Australia is already composed into simple shapes with analogous colors. The photographer's task is to discover them. (This is form-driven photography.)

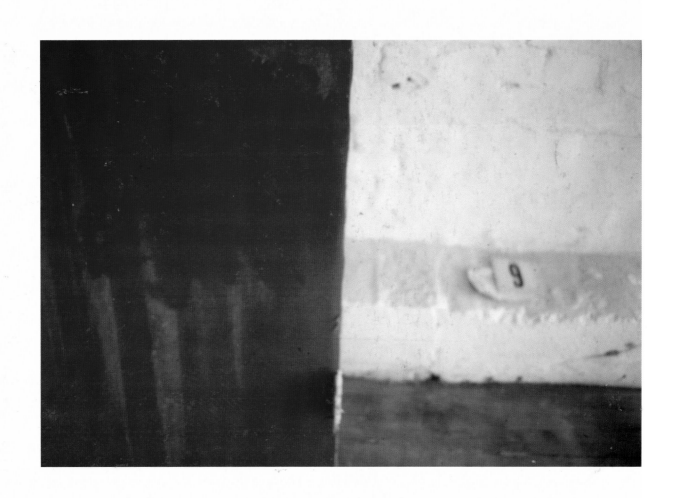

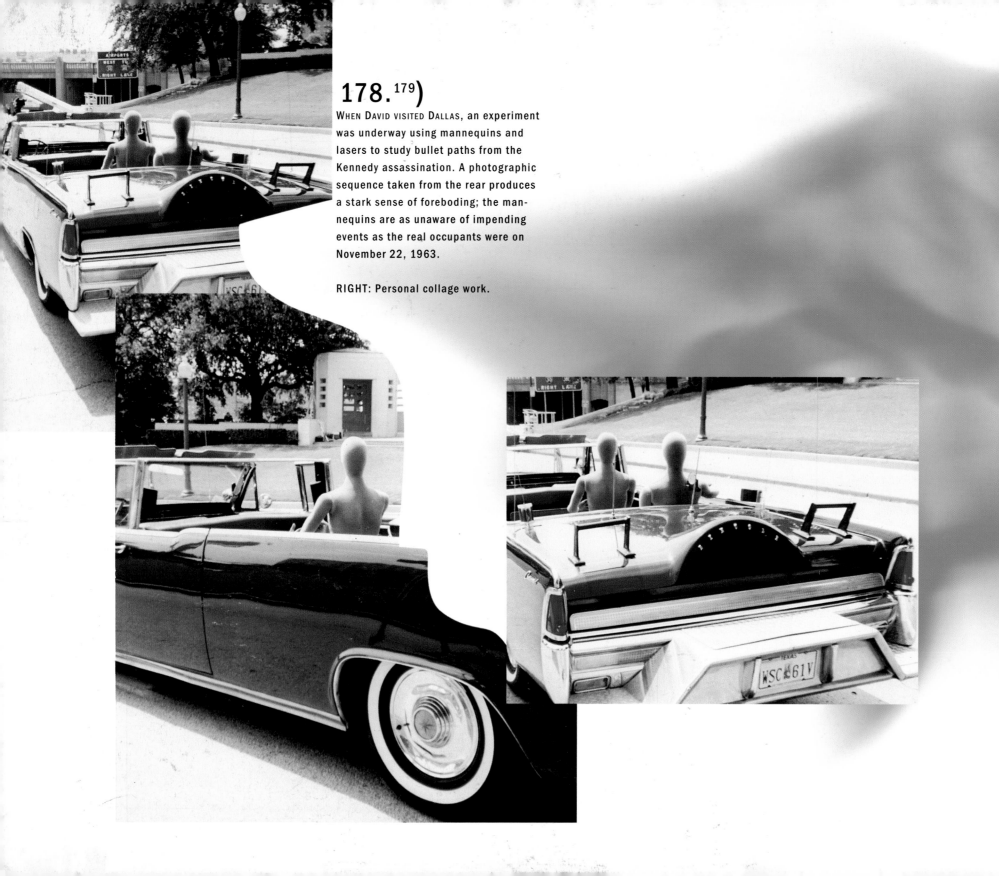

178. ¹⁷⁹)

WHEN DAVID VISITED DALLAS, an experiment was underway using mannequins and lasers to study bullet paths from the Kennedy assassination. A photographic sequence taken from the rear produces a stark sense of foreboding; the mannequins are as unaware of impending events as the real occupants were on November 22, 1963.

RIGHT: Personal collage work.

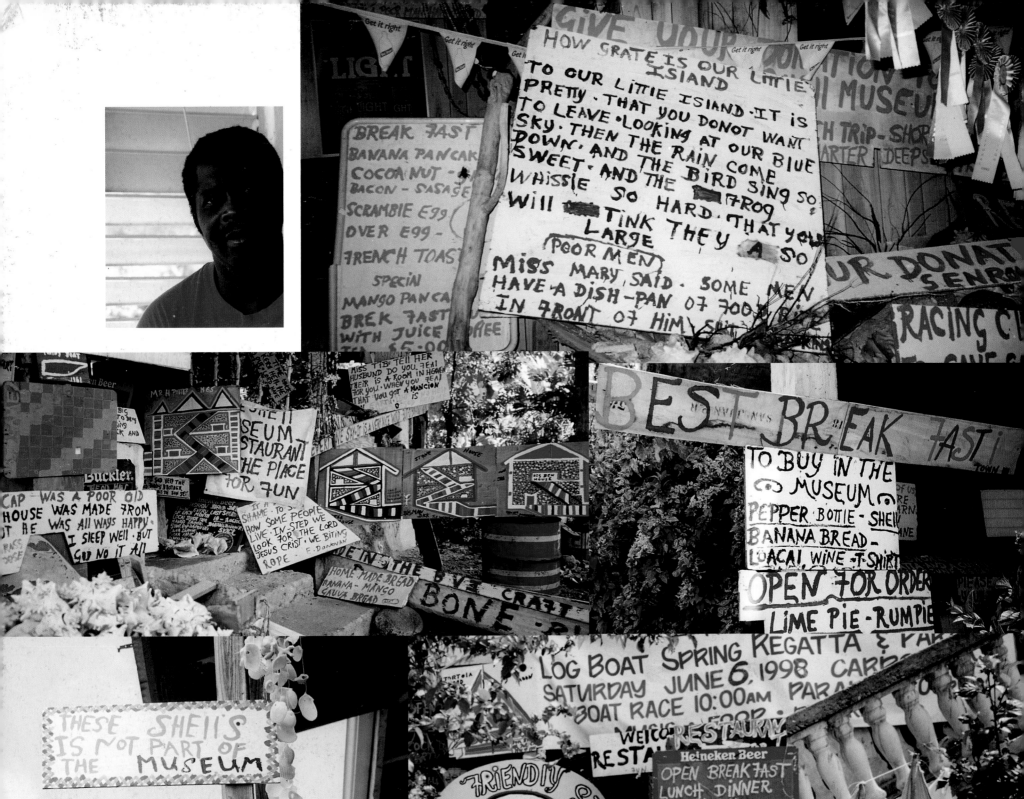

WELCOME TO THE SHELL MUSEUM
RESTAURANT · BAR
CALL 89-54704

HOME GROWN FRUIT
SERVES BREAKFAST
DON'T MISS IT JIM

Vernacular signs come from the heart. They are as direct and unassuming as everyday speech. Professional signs come from the brain and are as studied as a theatrical production, whether planned and fabricated by craftsmen trained in the sign shop tradition, or designed by graduates of design schools who are card-carrying members of the Society of Environmental Graphic Designers.

For the maker of homemade signs, these objects are not just messages, they are critical components for the family's economic survival.

DC: "Egberth Donovan records the oral history of his island in the signage for his restaurant, museum, and bar. If you ever get to Carrot Bay in the British Virgin Islands, do not miss experiencing the 'Shell MUSEUM'."

listen

The enigma of the unknown. Out-of-focus and cropped too closely to reveal any identifying shape and structure, photographs of a seashell become a study in color, not form.

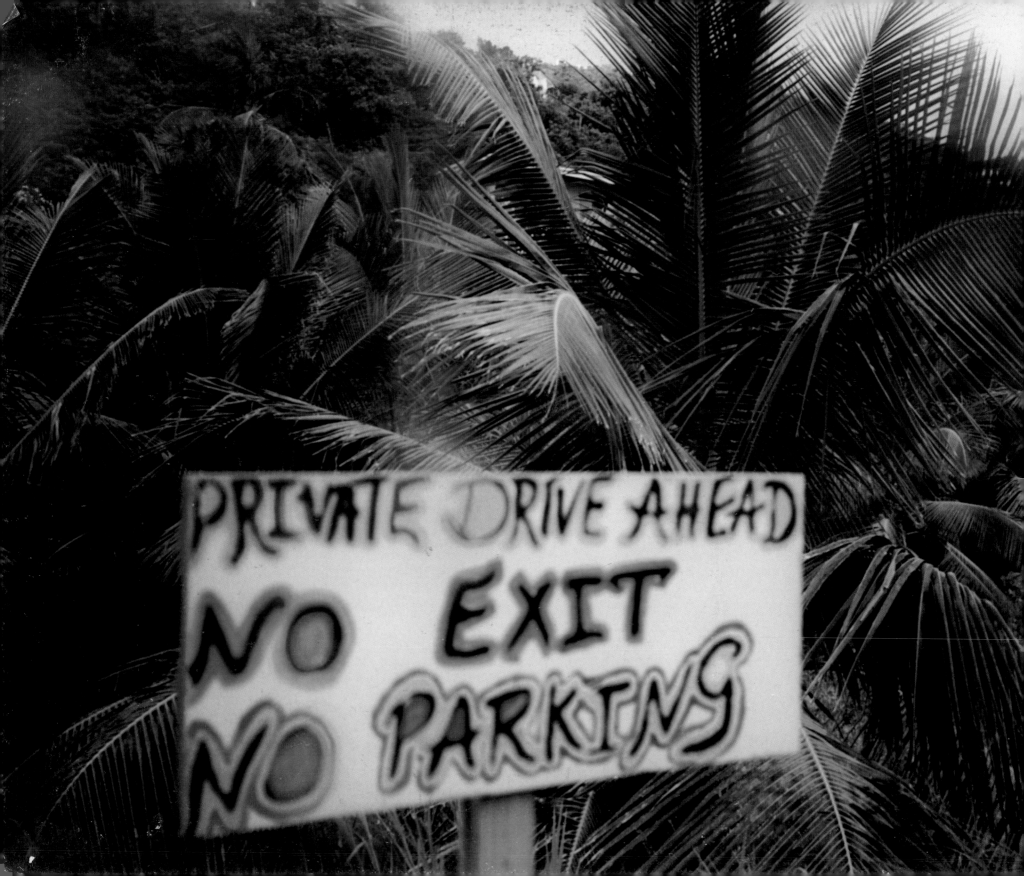

184.185)
Warm warning.

ROOM WITH A VIEW. FRANCE, 1998.

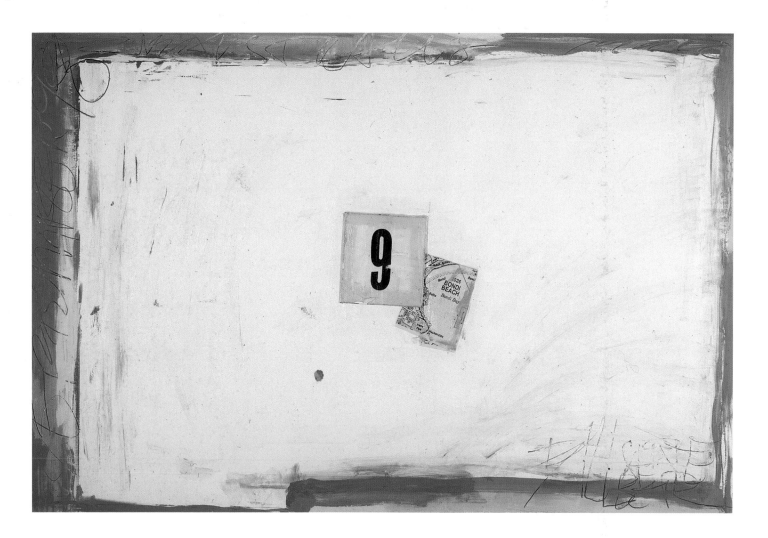

David Carson. Australia, 1998.

Artists constantly recycle their material, even moving it between media. The "9" in David's first painting is the same "9" in the photograph on page 177.

"....the word stylehas been corrupted"

" Today the word style is often used to define superficial surface charac-teristics, which are sometimes dictated by marketing considerations. Its original meaning—distinctive excellence of artistic expression achieved by appropriate forms and their relationships to one another in space—has been corrupted." [1]

[1]Philip B. Meggs, A History of Graphic Design, Third Edition, New York 1998, p. xi.

Out-takes

As I worked on the text for this book, David hammered away at the design process and added and subtracted photographs and pages at a fierce rate. The following thoughts are from spreads that ended up in the recycle bin:

Two photographs each conveyed a vastly different impression of the same city. Does having just one view (or viewpoint) always mislead us?

Fleeting encounters occur every day, but we are often too busy or too preoccupied to see them. Seldom does one respond with a light-fixing device, preserving the moment for others to experience.

Photographs become mnemonic devices. One Buenos Aires photograph reminded me of the polluted air in Argentina's capital. Thousands of Fiats without pollution controls contaminate the streets.

Unlike sanitized hotel rooms, living spaces become depositories of life's fragile passage, accumulating information.

dc+pm, nyc, fall 1998. foto: corinna pu

Philosopher Vilém Flusser wrote: "If images are to be deciphered, their magical character must be taken into account. It is a mistake to decipher images as if they were 'frozen events'. On the contrary, they are translations of events into situations; they substitute scenes for events. Their magical power is due to their surface structure, and their inherent dialects, their inner contradictions, must be appreciated in the light of this magic they have."1

1Vilém Flusser, *Toward a Philosophy of Photography*, Göttingen 1984, p. 7.

time out from the Iceland workshop for a surf check, fall 1998
: no one out, off-shore wind, good size, cold.

PHILIP MEGGS' ACKNOWLEDGMENTS:

At Virginia Commonwealth University, Richard Toscan, Dean of the School of the Arts, and John DeMao, Chairman, Communication Arts and Design Department, have provided crucial support for my research.

The teachings and writings of Nic Apgar, Richard Carlyon, Edmund Carpenter, Buckminster Fuller, John T. Hilton, and Marshall McLuhan have had a major impact upon my thinking. I sense traces of their inspiration everywhere.

Libby Phillips Meggs has been a constant source of encouragement and support. Her critical reading of the manuscript resulted in significant improvements.

Laurence King of the Calmann and King publishing house is a prince among publishers. Jane Tobin edited with sensitivity and care.

David Carson invited me to work with him on this book and has been a delightful collaborator whose good humor, openness to possibilities, and flexibility made for an extraordinary experience. It was stunning to watch proof after proof become richer and fuller. Thank you, David.

DAVID CARSON'S ACKNOWLEDGMENTS:

The teachings and/or graphic design and writings of Jackson Boelts, Hans Rudolph Lutz, El Lissitzky, Theo van Doesburg, Piet Zwart, H.N. Werkman, Willi Kunz, Chip Kidd, Ed Fella, Karrie Jacobs, and Mark Rothko.

SPECIAL THANKS: Skyview Studios, Chicago: Pete Jannotta, John Truckenbrod, Cassie Scroggins, Jessie Jacobs, Fred Pienkos. A more talented/friendly crew I've yet to find.
Atlantic/Lava Records: David Garza, Bryan Basham, Mike Oko, dp Eric Schmidt.
Kieran Walsh at Manhattan Transfer, New York for his help with Citibank, Ameritrade TV.
Backe/Meixner/Gross (keep an eye on these folks 3d multimedia access from Frankfurt.)
Corinna Pu kept, and keeps, things running. And gets me places. Often on time.

ESPECIALLY Christa, Luke, and my parents, Bob and Dorothy.

AND Laurence King and Jane. ALSO: Phil Meggs: made this a better book. And he's a nice guy. And funny. I'm honored to have worked with him. There is no better voice speaking for, or about, Graphic Design and Graphic Designers. And HE can design.

FONT DESIGNERS: Miles Newlyn, John Langham, Josh Darden, Timothy Glaser, Morris F. Benton, Claude Garamond, Jean Jannon, Zuzana Licko, Linn Boyd Benton, Adrian Frutiger, and Claudio Piccinini

FONTS/typefaces: FOR THE LATEST FONT BROCHURES/INFORMATION, CONTACT:
Plazm Fonts: phone: 1.800.524.4944/e-mail: fonts@plasm.com
Garage Fonts: phone : 1.619.755.3913/e-mail: info@garagefonts.com

All fotos were shot with my Olympus Stylus. No software programs were utilized in the photographs, just my "point and shoot" and my local one-hour foto lab. (1/2 hour in Iceland, PLUS free film).

Thanks to all of you who continue to support these books – they're fun to do. And for the zillions of notes and e-mails about the first 2 books (i may not answer ALL, but i try, and i do read 'em). Thank you for your continued support and insights.

Any graffiti artists whose work was photographed: please contact me (address below) so we can credit you in future printings.

AND: If you'd like your work considered for FOTOGRAFIKS 2, send NON-RETURNABLE samples to:
david carson design (ATT:FOTOGRAFIKS2), 27 w20th #501, nyc ny 10011, usa.

Published 1999 by
Laurence King Publishing
an imprint of Calmann & King Ltd
71 Great Russell Street, London WCIB 3BN
Tel: + 44 020 7 831 6351
Fax: + 44 020 7 831 8356
e-mail: enquiries@calmann-king.co.uk
www.laurence-king.com

Images and design © 1999 David Carson
Text © Philip B. Meggs
This book was produced by
Calmann & King Ltd., London

A catalogue record for this book is
available from the British Library.

ISBN (p/back) 1 85669 171 3
ISBN (h/back) 1 85669 194 2

Printed in Singapore